TOBERMORY

Nic Davies has worked in wildlife conservation and animal welfare since 1989. He now lives on Mull, engaged in photography, wildlife guiding and the conservation of otters and marine species. His images have featured in publications and TV programmes worldwide.

Samantha ('Sam') Jones is a landscape photographer who lives on Mull. She was RNLI Photographer of the Year in 2011. She was commended in the Landscape Photographer of the Year in 2012 and was a finalist in the Scottish Nature Photography Awards in 2013, 2014 and 2015.

Brian Swinbanks is an industrial and graphic designer. He has designed children's toys at Raleigh Bicycles and was awarded with brother Duncan a British Design Award. He has run his own charter boat business and is Chair of the Tobermory Harbour Association.

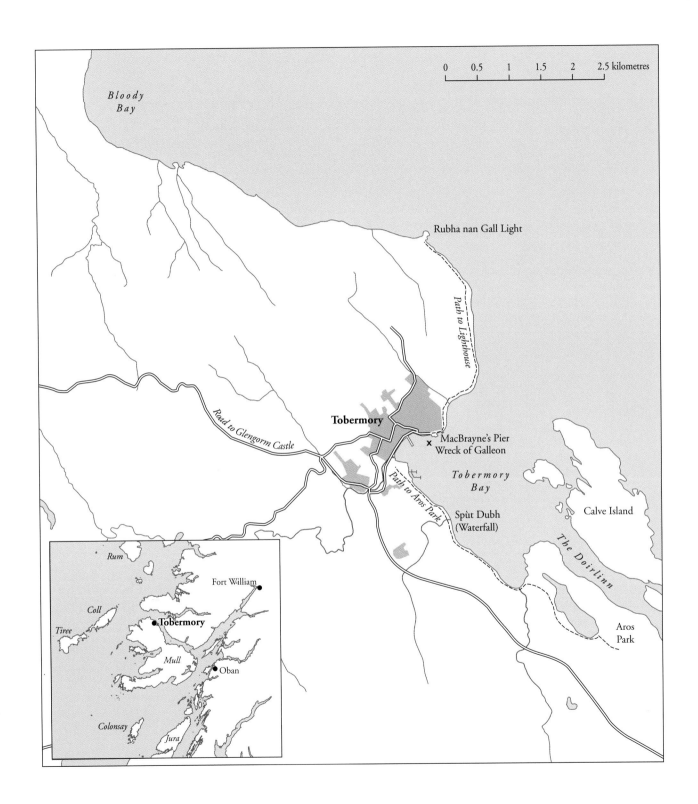

Bloody
Bay

0 0.5 1 1.5 2 2.5 kilometres

Rubha nan Gall Light

Path to Lighthouse

Tobermory

Road to Glengorm Castle

MacBrayne's Pier
Wreck of Galleon

Path to Aros Park

*Tobermory
Bay*

Spùt Dubh
(Waterfall)

Calve Island

The Doirlinn

Aros
Park

Rum

Fort William

Coll

Tobermory

Tiree

Mull

Oban

Colonsay

Jura

TOBERMORY

Nic Davies, Sam Jones and Brian Swinbanks

BIRLINN

First published in Great Britain in 2016 by
Birlinn Ltd

West Newington House
10 Newington Road
Edinburgh
EH9 1QS

www.birlinn.co.uk

ISBN: 978 1 78027 315 0

British Library Cataloguing-in-Publication Data
A catalogue record for this book is available on
request from the British Library

Layout by Mark Blackadder

Printed and bound by Latimer Trend, Plymouth

PREFACE

I first fell in love with Tobermory in 1974. From the moment I lowered an anchor down through the gentle waves, I knew that this was to become a perfect home. My motorboat was now snug and secure and forever firmly attached to the seabed. I was surrounded by an iconic and colourful harbour, famous for the elusive wreck of a Spanish Armada galleon and for its Hebridean hospitality.

Tobermory is the perfect port. The harbour and the upper village were founded for herring fishing in 1788. It was built for sailing ships, paddle steamers and for the horse and cart (definitely not for the motorcar!). The historic town established itself slowly, moving north from the distillery and following the contours of the bay to finish at the Mishnish Pier in 1864.

By 1974, enterprising locals and dynamic incomers were together building and opening new shops, new houses, local food restaurants and island business. I soon realised that I had moved into a community that cares, a community that believes in helping itself.

When a new Community Harbour Association was founded in 1983, I was elected chair. By this stage, change was in the air. The seabed was reclaimed at Ledaig to prepare Tobermory for the motor age. The harbour was reorganised to accommodate hundreds of local and visiting boats. Pontoons were installed to allow visitors to step ashore. Cruise liners were made welcome and this time new buildings followed the landscape south from the distillery.

Birlinn has produced a perfect book about Tobermory today, showcasing the people and the fabulous wildlife to be seen in and around our harbour.

Brian Swinbanks

Aerial View of Tobermory

Tobermory takes its name from Tobar Mhoire (Mary's Well) and was a small hillside settlement from ancient times.

In 1788 today's town was founded as a planned village for the herring industry. Over the years it has become a prosperous island capital. This prosperity is mainly due to the distinctive, colourful Main Street which hugs a wonderful natural harbour.

Tobermory is a haven for mariners, an amazing home for wildlife and a captivating place to live.

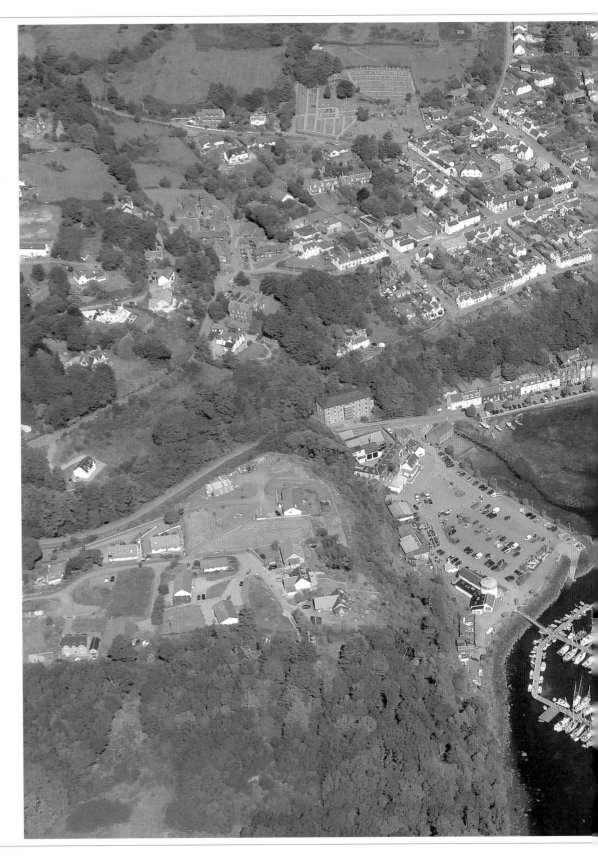

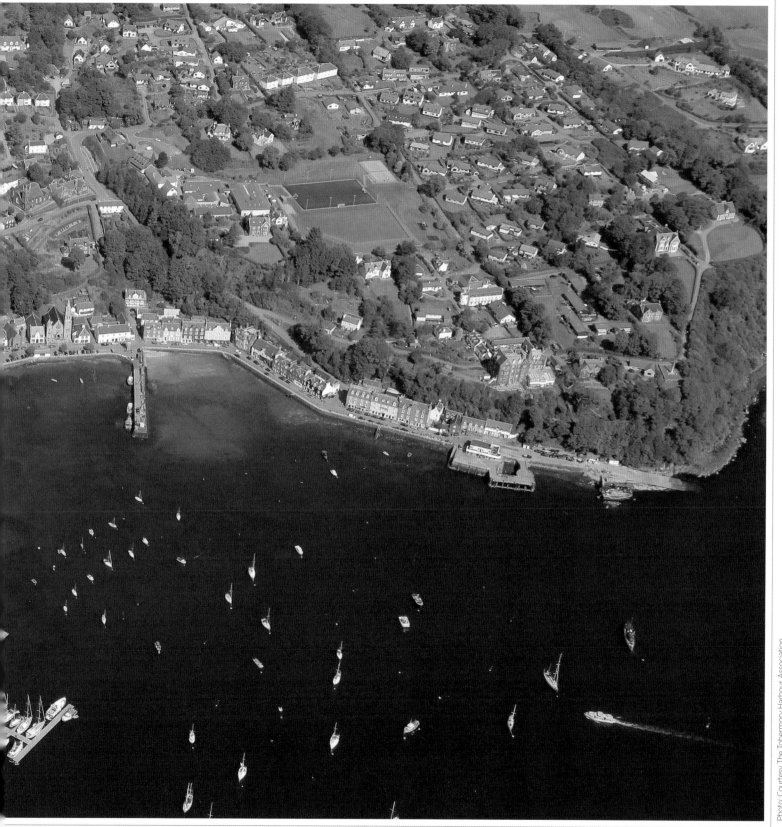

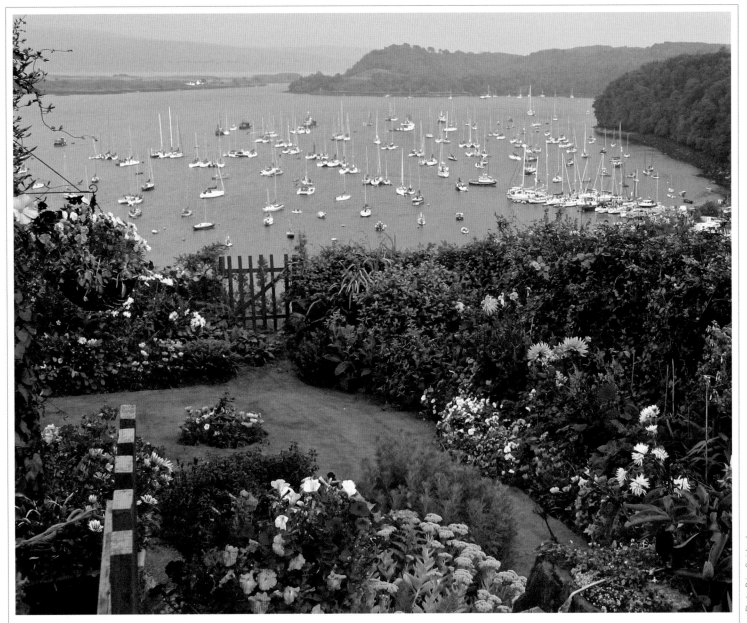

Tobermory Harbour from Argyll Terrace

Looking across Tobermory Bay towards Aros Park
from above the Main Street. The bay is one of the most
sheltered in Scotland.

The Navy established a base here to train ships'
crews for the war in the Atlantic. In charge was
Commodore (Vice-Admiral retired) Stephenson, who
became a legend and was the subject of a book by
Richard Baker called *The Terror of Tobermory*.

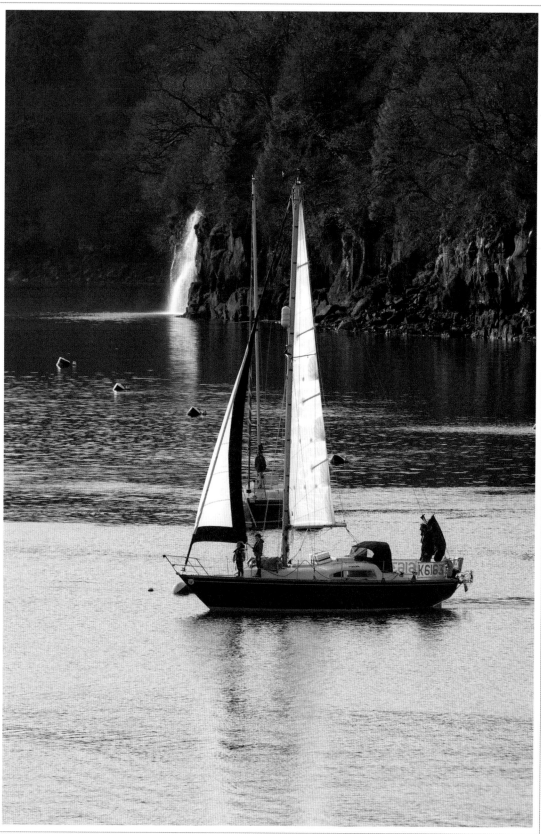

Sput Dubh in Full Flood

A constructed path winds round the west of Tobermory Bay to Aros Park. About halfway along is the waterfall Sput Dubh (Black Spout). It was from this waterfall that the Navy filled its water boat during the war. In the foreground is the yacht *Piseag* (Gaelic for cat or kitten), sailing out of Tobermory Bay.

Unexpected Tranquility

The land adjacent to the south side of Tobermory Bay was purchased in 1959 by the Forestry Commission. Known as Aros Park, this is a magnificent area of woodland walks and spectacular waterfalls. Open to the public, this is a jewel in the crown of Tobermory. Apart from the path round the bay, the park can be accessed from the main road just outside Tobermory.

Photo: Brian Swinbanks

Upper Falls, Drumfin

One of the many waterfalls of Aros Park, the Upper Falls are spectacular after rain and even more so in autumn colours. The Forestry Commission have built a magnificent viewing platform that gives a stunning view of the falls and landscape to the north-east.

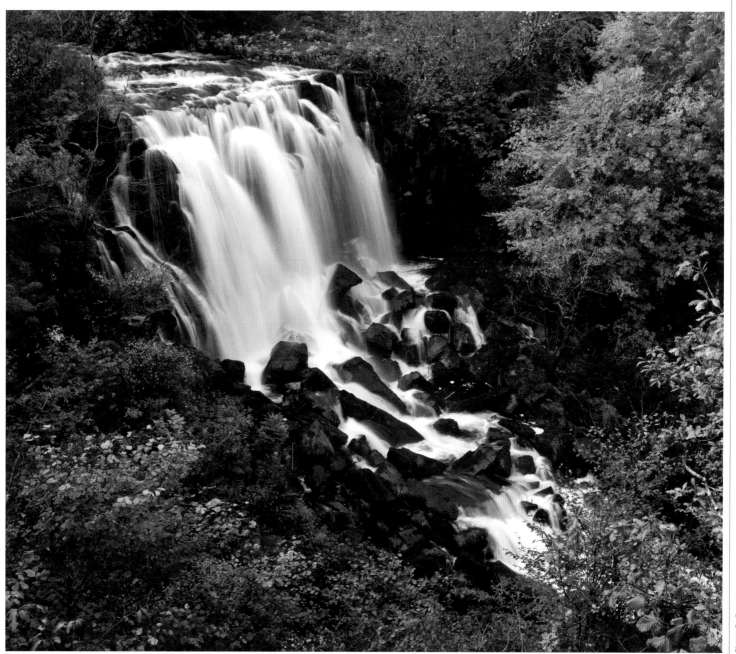

Photo: Dr Sam Jones

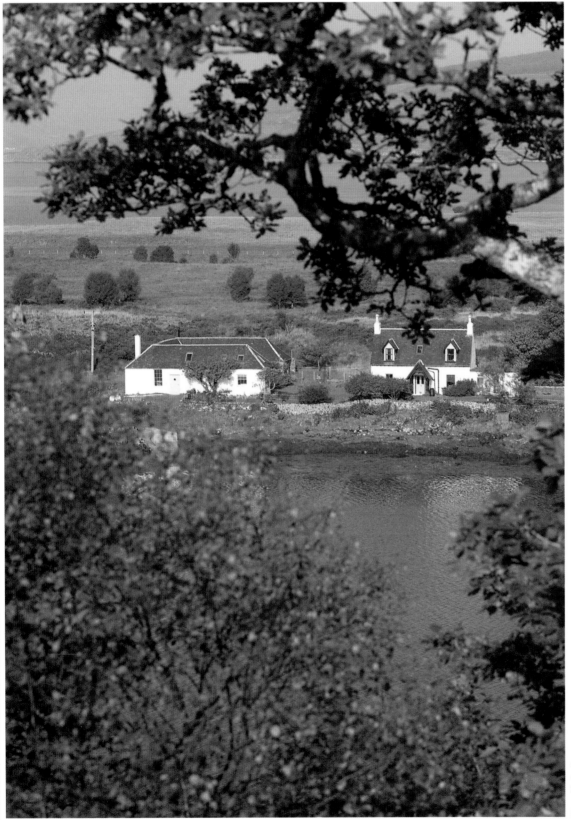

Calve Island from Aros Park

Aros Park is the closest point on Mull to Calve Island, the island which almost closes Tobermory Bay. Calve Island, which was once a single farm, is now privately owned by the Cotton family, who stay during the summer months.

Photo: Nic Davies

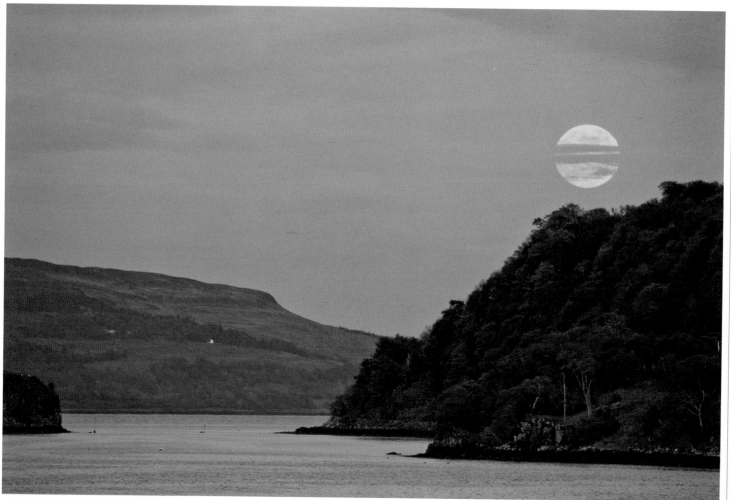

The Doirlinn in Moonlight

The narrow tidal channel that joins the
Sound of Mull to Tobermory Bay and
separates mainland Mull from Calve
Island is known as the Doirlinn (a ford
accessible at low tide at times). On the
lowest spring tides you can wade from
Aros Park to Calve Island.

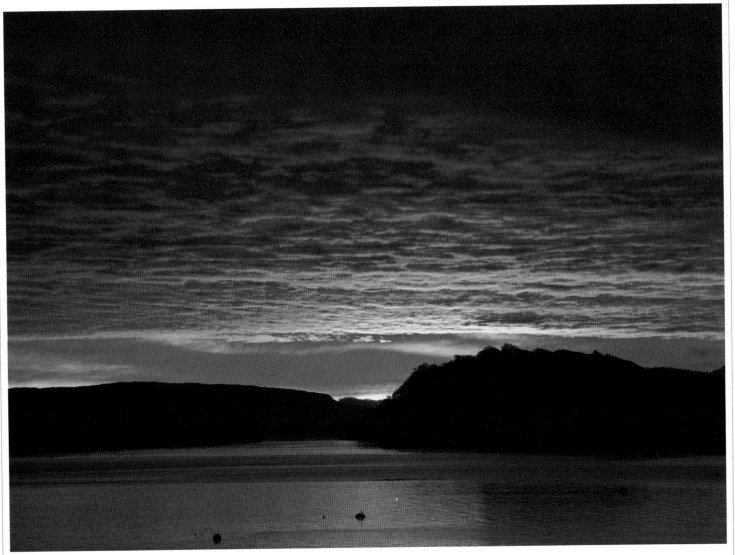

Sunrise over Tobermory Bay

The sky on fire at dawn. Another
day greets Tobermory.

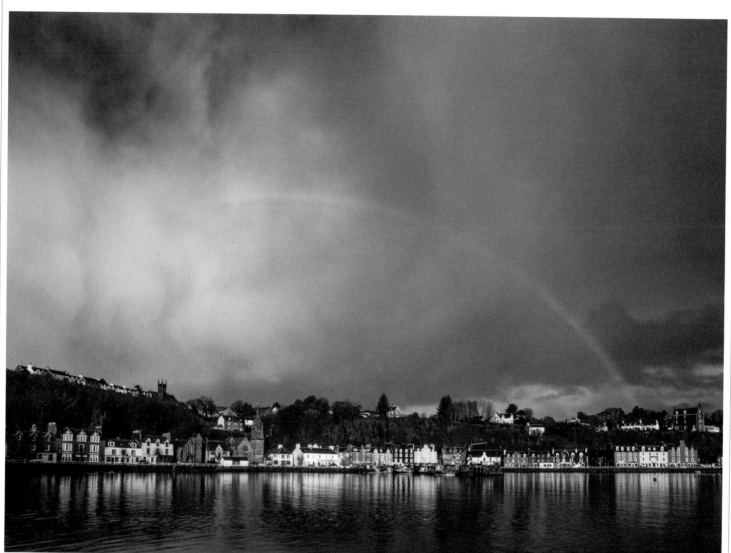

The Colour of Tobermory

The colours of the rainbow arch the colourful houses of Tobermory. The main aspects of the harbour front were completed by 1862 but the colourful frontage didn't arrive until much later.

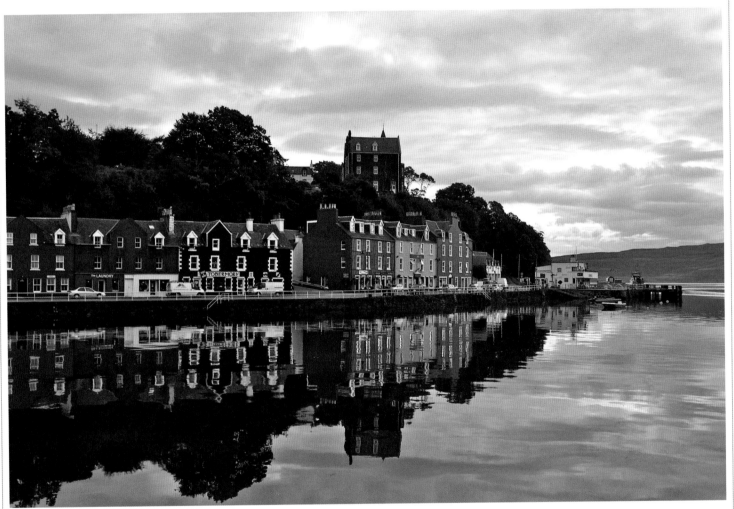

Photo: Brian Swinbanks

Reflections

Bobby MacLeod, last Provost of the Burgh
of Tobermory, painted the Mishnish Hotel
its iconic yellow colour. He wanted the
building to be a 'beacon' to boats
approaching from up the Sound of Mull:
a welcoming hostelry before turning west
and heading out towards wilder, open
waters.

Fishermen's Pier

The Fishermen's or Old Pier was built between 1812 and 1814 and followed the same model for construction as the sea wall. It is still in everyday use today. A favourite local pastime is walking the pier and greeting any hardy fishermen returning with their catch.

Sunset over Main Street

Tobermory is built on shore reclaimed from the harbour. This is held in place by a sea wall of 'robust stone construction'. It was none other than Thomas Telford who advised on the design of the wall in 1790. Testimony to his skills sees the wall standing in pristine condition hundreds of years later.

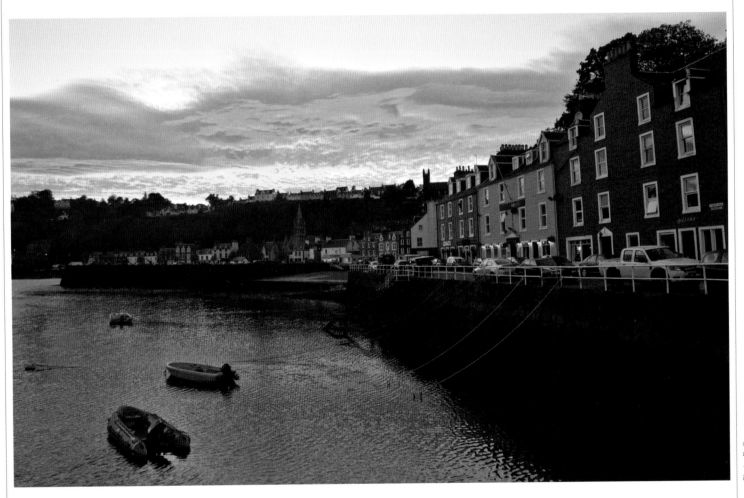

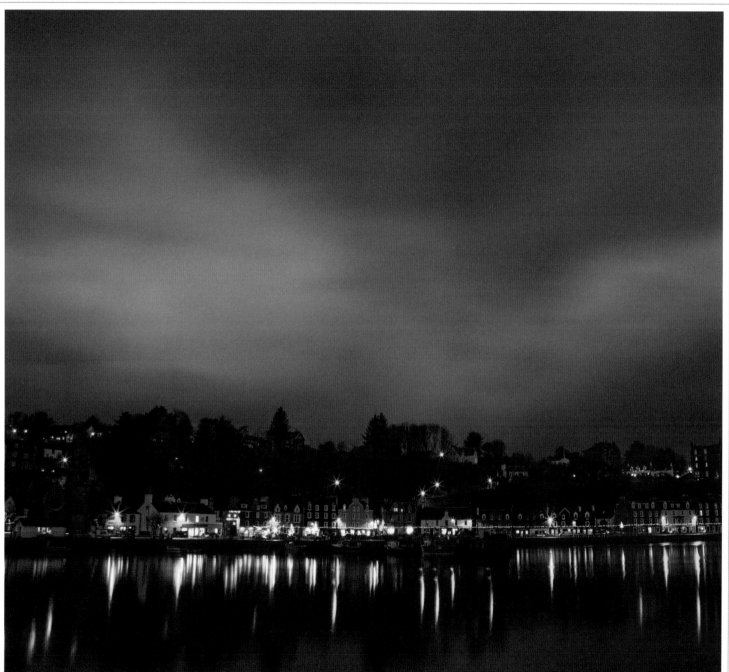

Lighting Up Time

Tobermory Main Street in the evening. The street is alive with people enjoying the views and visiting the many eating places and pubs. Tobermory has a vibrant commercial sector supplying the many needs of the visitor.

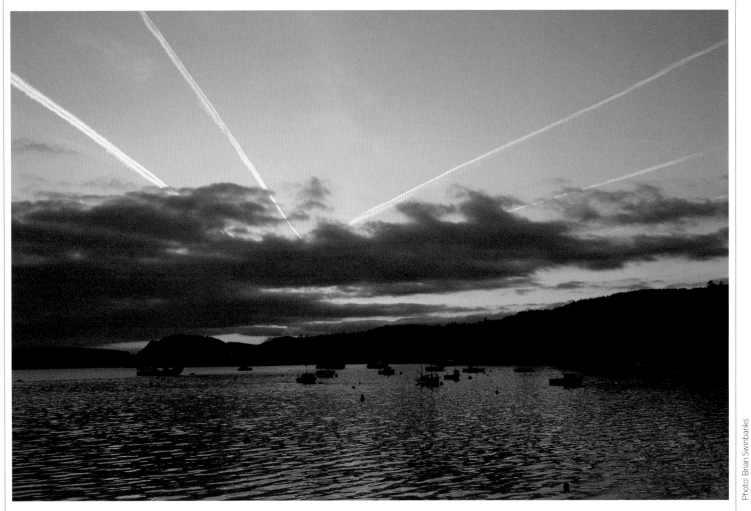

Photo: Brian Swinbanks

Pathway to the West

The skies above Tobermory are also part
of the 'Great Circle' route to America.
Once, great sailing ships called for ship's
biscuits and provisions before crossing
the Atlantic. Today airliners fly a similar
route overhead.

Pathway to the North

If you walk the Main Street east, you will come to a path out of Tobermory which follows the coast to the north. This is known as the Lighthouse Walk. At the end of the walk is Rubha nan Gall.

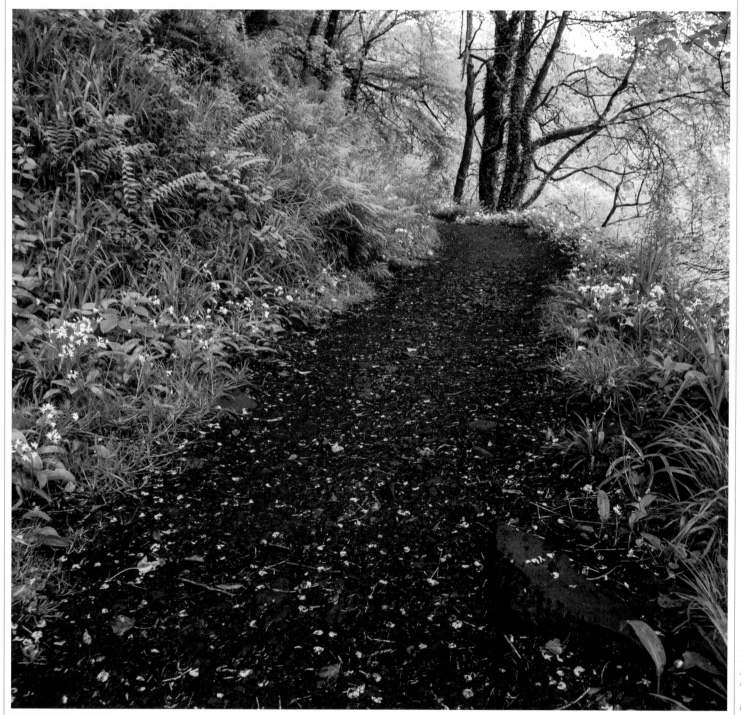

Photo: Dr Sam Jones

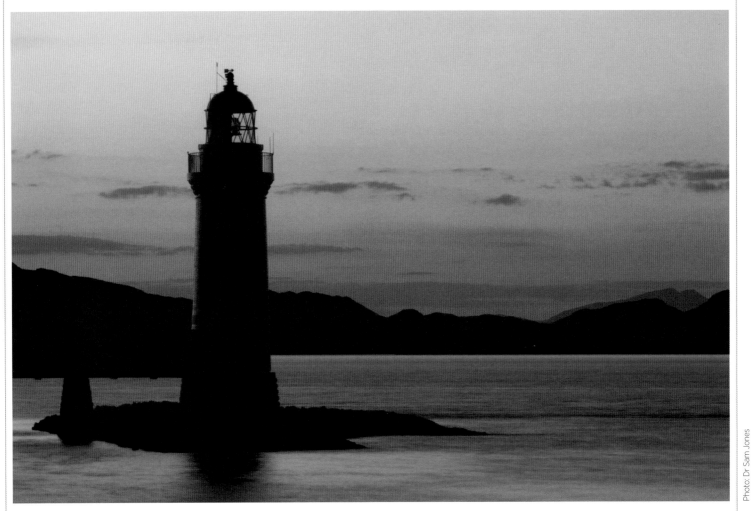

After Sunset, Rubha nan Gall

Rubha nan Gall (Cape of the Strangers) lighhouse was designed by David and Thomas Stevenson and first lit in 1857. Past the light is a magnificant panorama which includes the peaks of Rum.

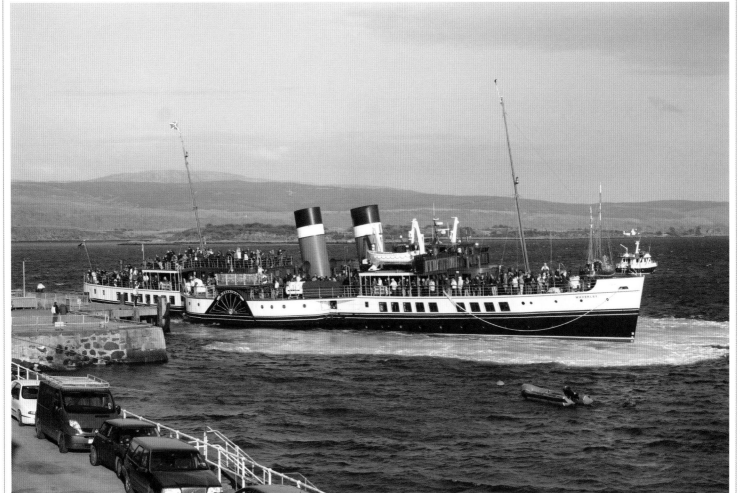

Photo: Brian Swinbanks

The *Waverley* Arrives

PS (Paddle Steamer) *Waverley* berthing at the MacBraynes Pier, Tobermory. The *Waverley* was built in 1946 and is named after Sir Walter Scott's first novel. The *Waverley* is the last seagoing passenger-carrying paddle steamer in the world and is a frequent caller at Tobermory. The first paddle steamers arrived in 1820.

Round the Buoys

West Highland Yachting Week is an historic sailing regatta that culminates in Tobermory. Over 1,000 competitors from around the world come to participate in what are the most scenic waters in Britain.

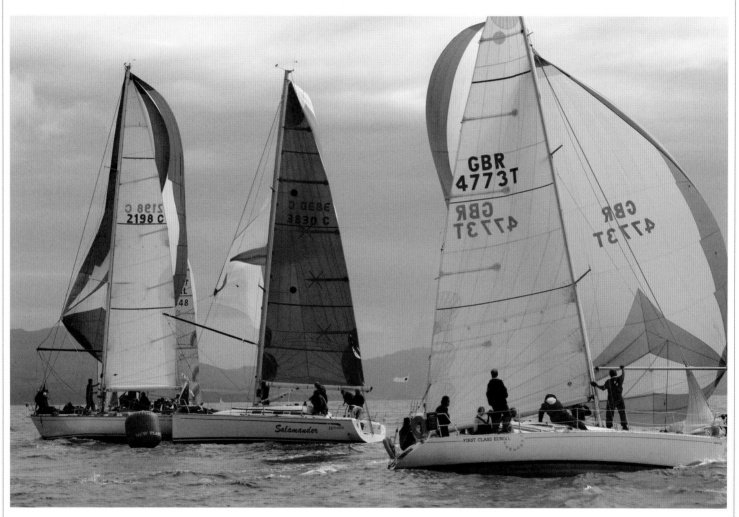

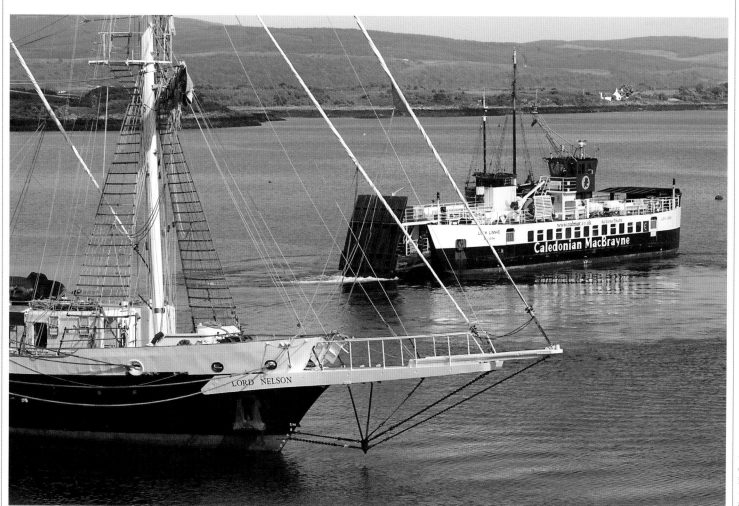

Photo: Nic Davies

The *Lord Nelson* tied up in Tobermory

The *Lord Nelson* was the first tall ship in the world to be designed and built to enable people of all physical abilities to sail side by side on equal terms. Tobermory is a popular destination for this great ship.

MV *Loch Linnhe* arrives in Tobermory

The ferry MV *Loch Linnhe* connects Tobermory to Kilchoan, a small village on Ardnamurchan, the most westerly part of the British mainland. In a quaint reversal of the usual, locals from mainland Kilchoan travel to Tobermory for their shopping. The slip for boarding and disembarking the ferry is at the far east end of Main Street.

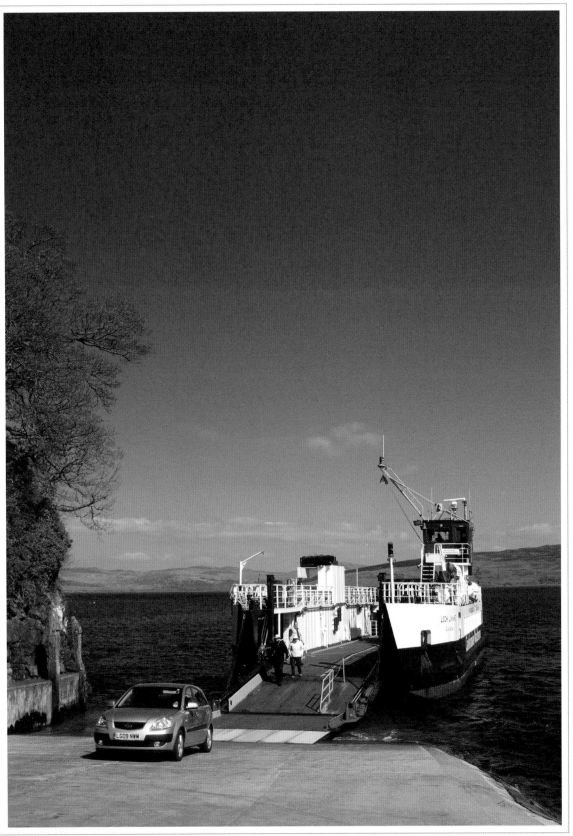

Photo: Dr Sam Jones

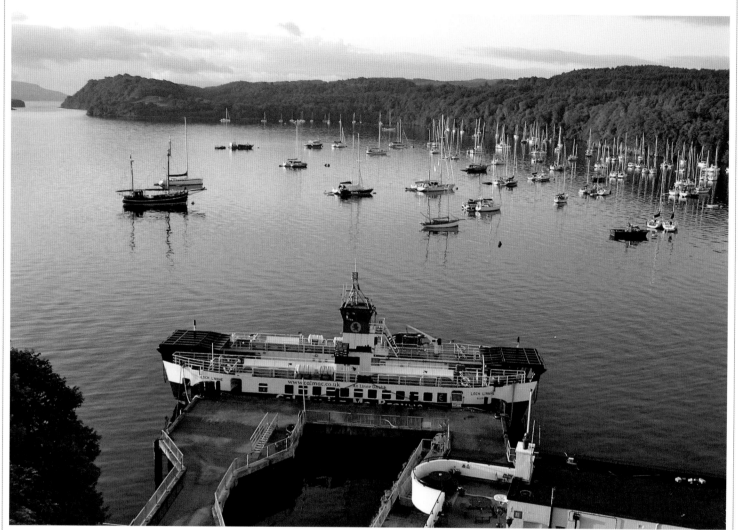

Photo: Brian Swinbanks

Kilchoan Ferry at the MacBraynes Pier

The MacBraynes or Mishnish Pier was built in 1862 and is now owned by Caledonian Maritime Assets Ltd. Known as CMAL, this company owns the ferries, ports and harbours, and infrastructure necessary for vital ferry services serving the west coast of Scotland. The MacBraynes Pier is a vital link to the sea and has an important symbolic meaning to the people of Tobermory. In the early 1980s the pier was threatened with closure. This incensed the normally easygoing population and after nationwide protests the pier was saved, rebuilt and extended.

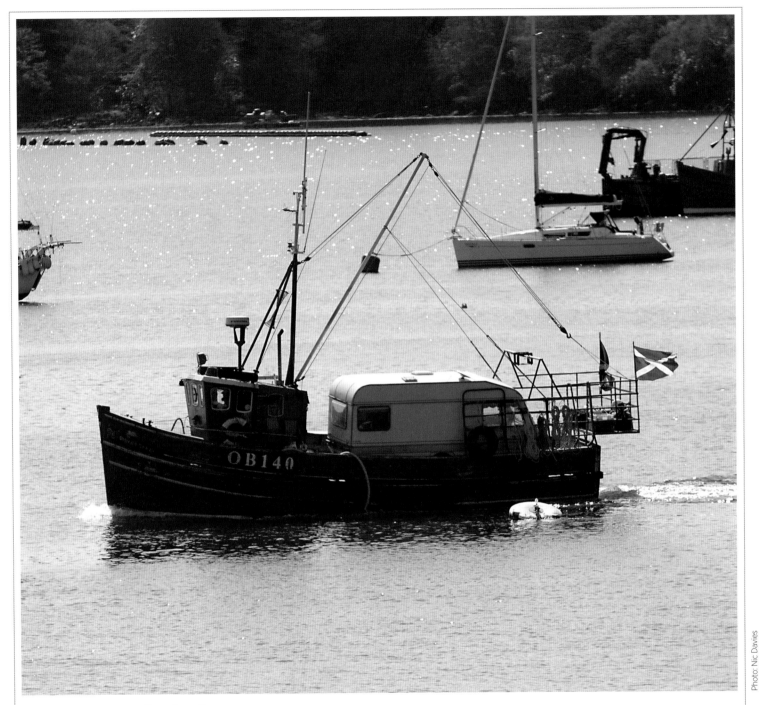

Photo: Nic Davies

Home from Home

Fishing boats and community
piers form a vital second link, after
ferries, between the islands and
the mainland, with often the most
unusual of transport jobs being
taken on!

Visitor from Afar

This yacht arrived in Tobermory after travelling right round the North West Passage from Seattle in the USA. An enclosed wheelhouse was essential for protection from the cold. Sailing by the wind, the traditional routes led to Tobermory as the first port in Europe.

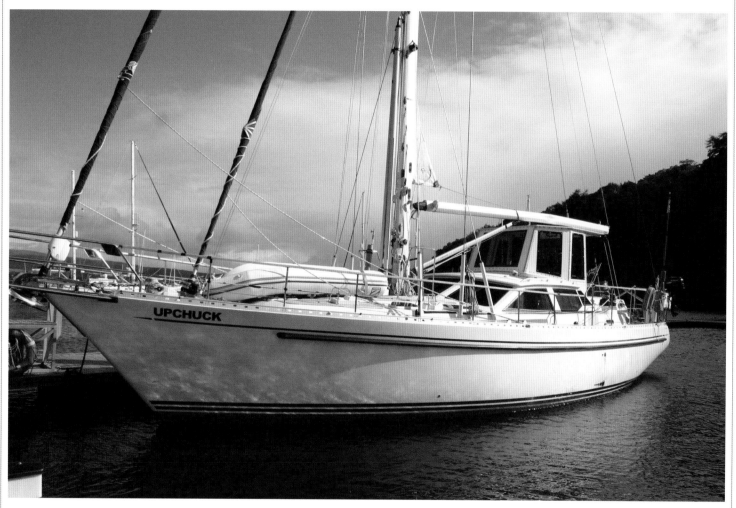

Photo: Brian Swinbanks

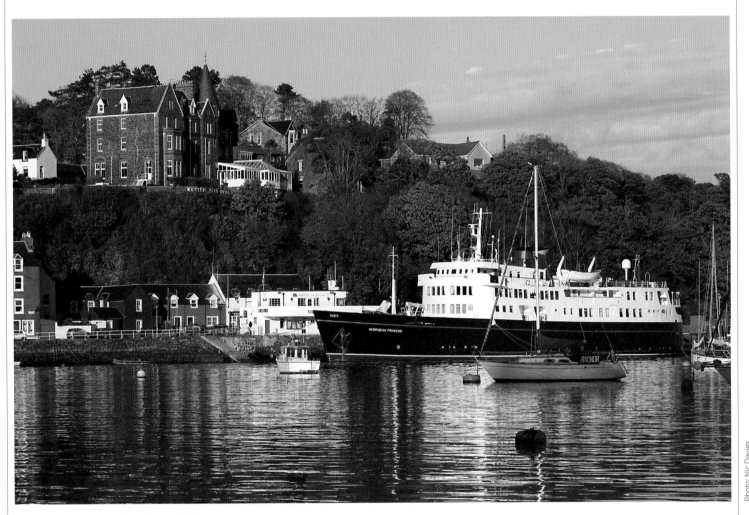

Photo: Nic Davies

Hebridean Princess

The cruise ship *Hebridean Princess* is a former Calmac ferry. Built in 1964 she was originally called *Columba* and sailed to Mull from Oban as a side-loading car ferry.

The modern ro-ro (roll-on/roll-off) ferry made her redundant and she was sold in 1988 to become a luxury cruise ship. Among her prestigious guests is the Queen, hosted on her Scottish holiday.

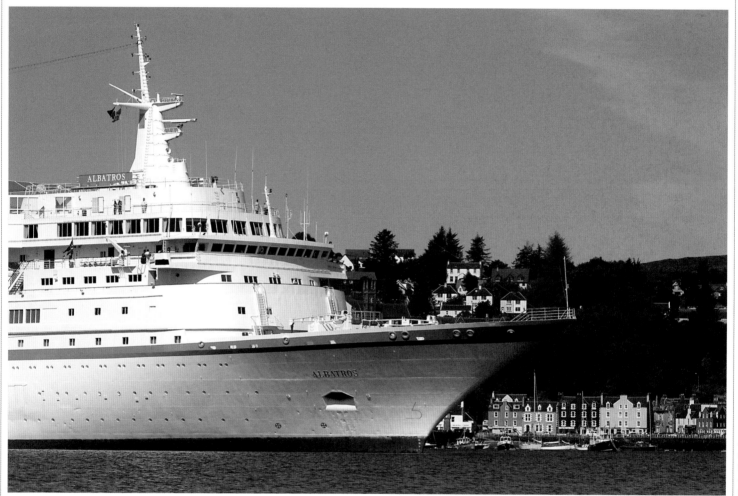

Photo: Nic Davies

The *Albatros* at anchor

Tobermory is a favourite port of call in the summer months for cruise liners. Weighing up to 30,000 tons and accommodating over 1,000 passengers, they anchor in the bay in favourable conditions.

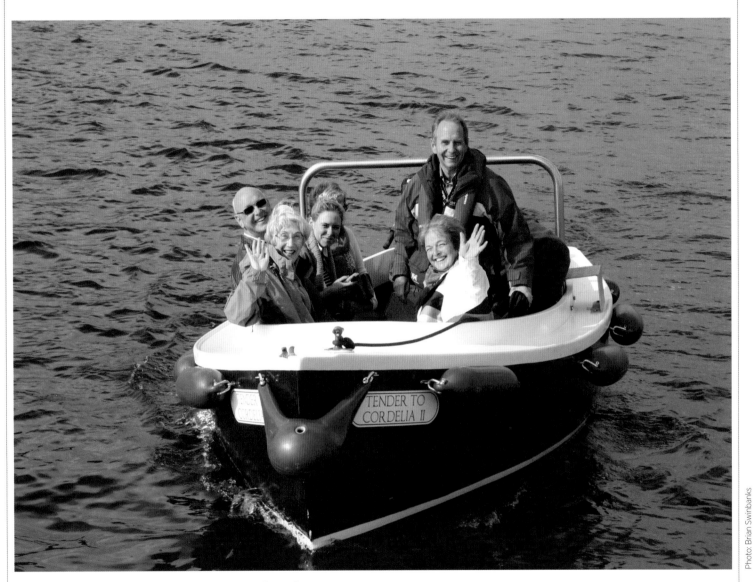

Happy Passengers

When larger boats arrive in
Tobermory the ship's tender
transports people and
supplies to and from shore.

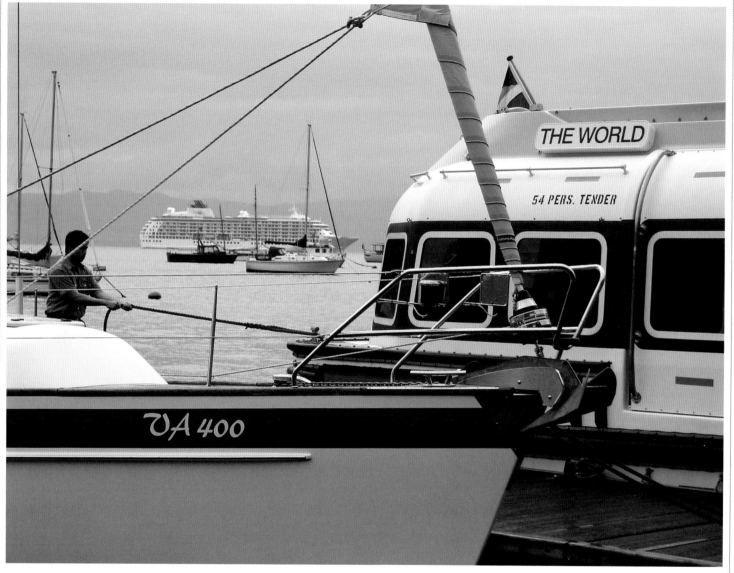

Photo: Brian Swinbanks

The World comes to Tobermory

Tender from *The World* lands at Tobermory. *The World* is a private cruise ship serving as a residential community and owned by its residents. Coming from about 19 countries, they live on board as the ship travels the globe.

The World can be seen in the distance. Very large cruise liners anchor just outside the bay in the Sound of Mull. Passengers are brought ashore by ship's tender to the pontoons.

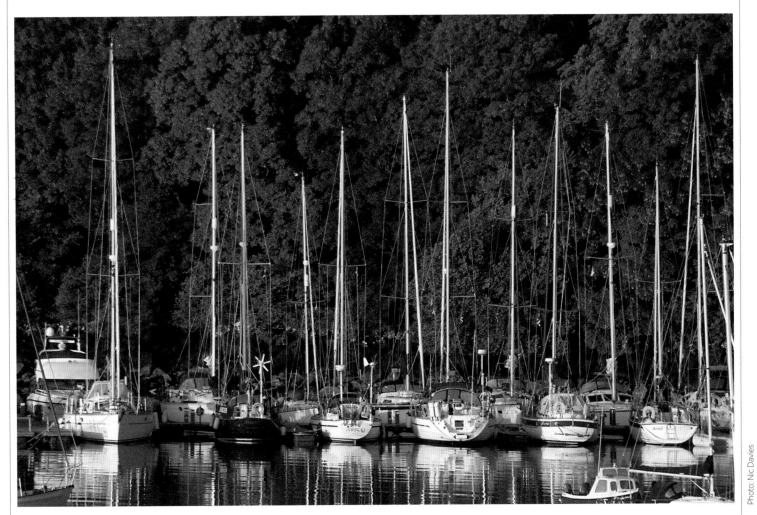

Photo: Nic Davies

Massed Masts

Visiting yachts on Tobermory's pontoons. The pontoons are owned and managed by a local community organisation called the Tobermory Harbour Association. Using these community owned facilities, over 4,000 yachts and motor boats visit Tobermory every year.

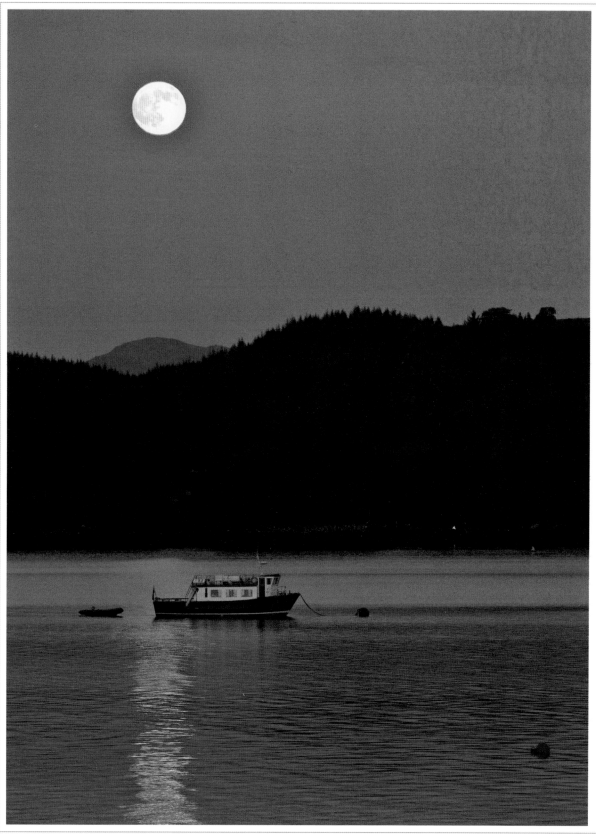

Moonrising

A full moon rising, with Beinn Talaidh far away in the distance. The mountain was a Corbett (mountain between 762m and 914.4m) for many years before a resurvey demoted it to the ranks of the Grahams (mountains between 609.6m and 762m).

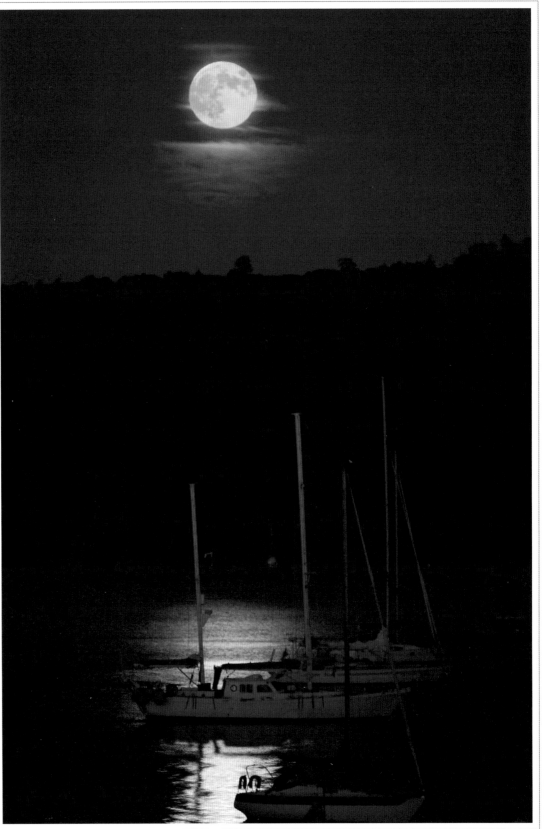

Moonshine

Looking south, the moon and stars often create glorious reflections in the calm waters of the bay. Here the full moon is illuminating *Silurian*, the research yacht of the Tobermory-based Hebridean Whale and Dolphin Trust.

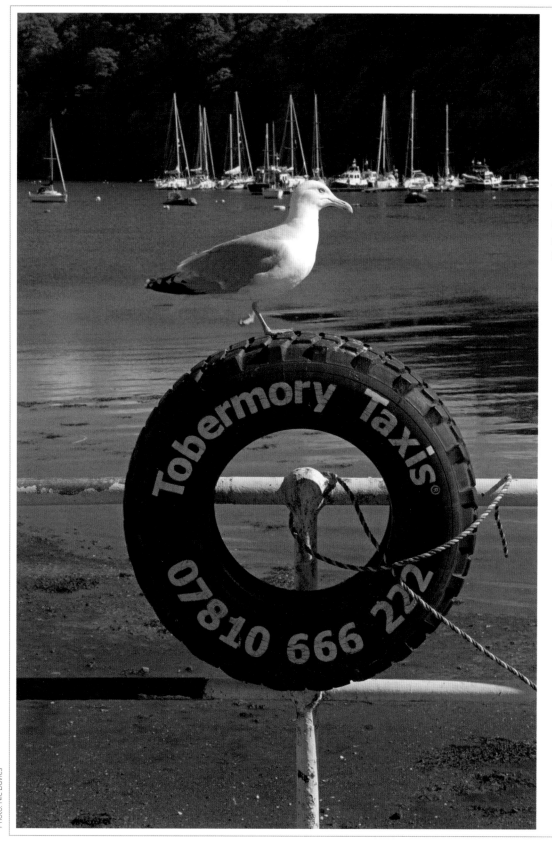

Taxiing for Take-off

With most of residential Tobermory situated up steep slopes, locals often take advantage of the taxis parked next to the town clock.

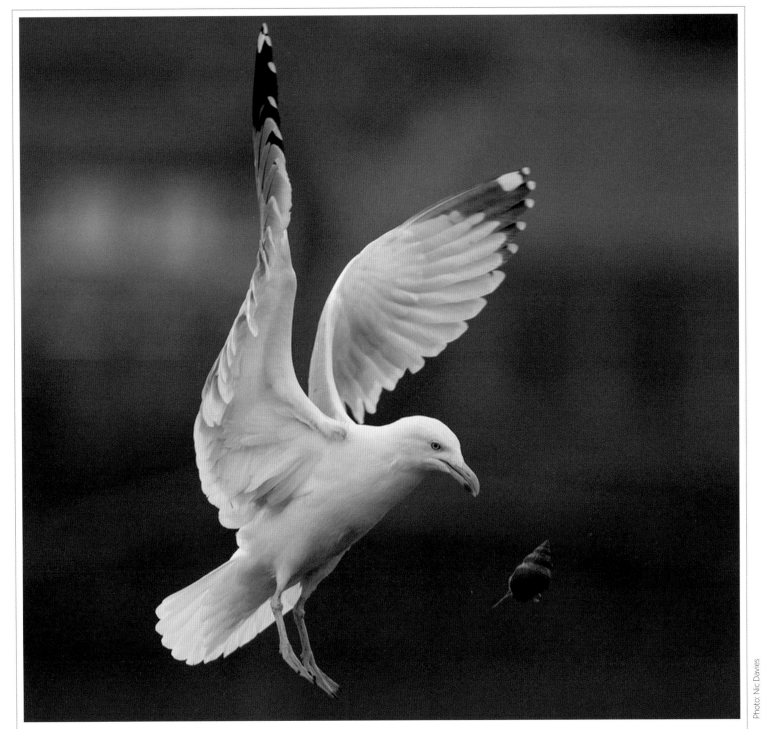

Road Kill

A herring gull dropping a whelk onto Main Street to break its shell. Wildlife and the day-to-day goings-on in Tobermory live in harmony.

Photo: Nic Davies

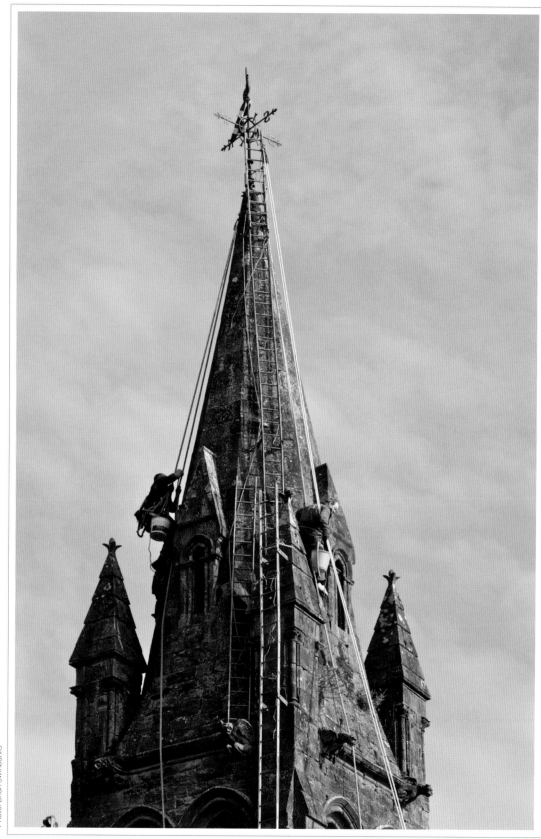

Repairing the Gallery Steeple

Two local men hang high above Main Street as they repair and clean the tallest building in Tobermory.

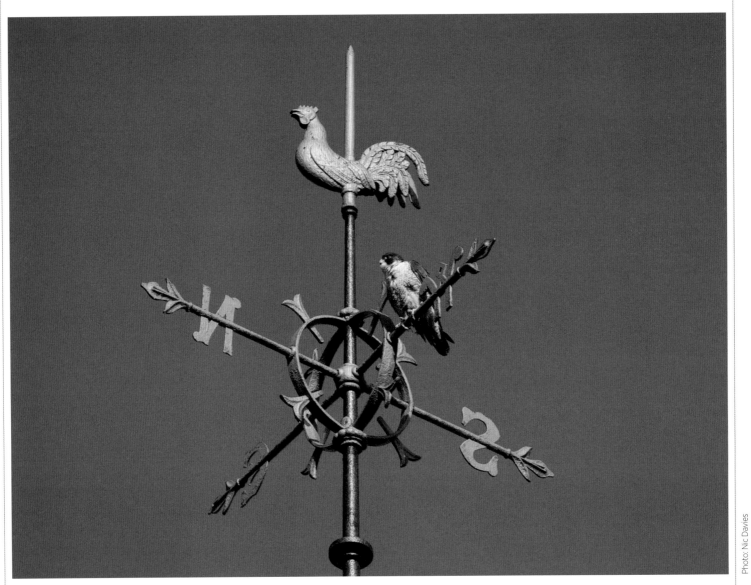

Vane Male

A male peregrine falcon
takes up pigeon-watch
from the highest vantage
point and waits patiently
for that passing meal.

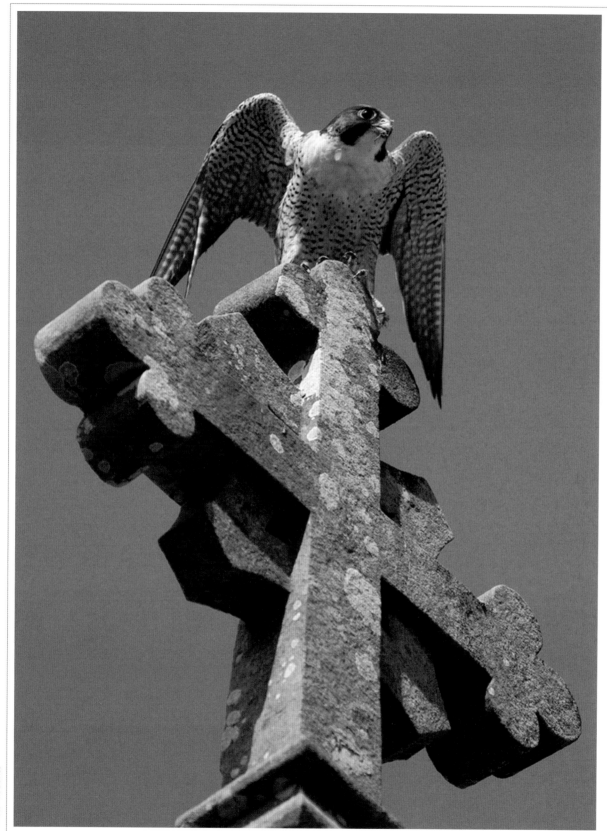

Eye on the Prize

The peregrine spots its prey from the stone cross.

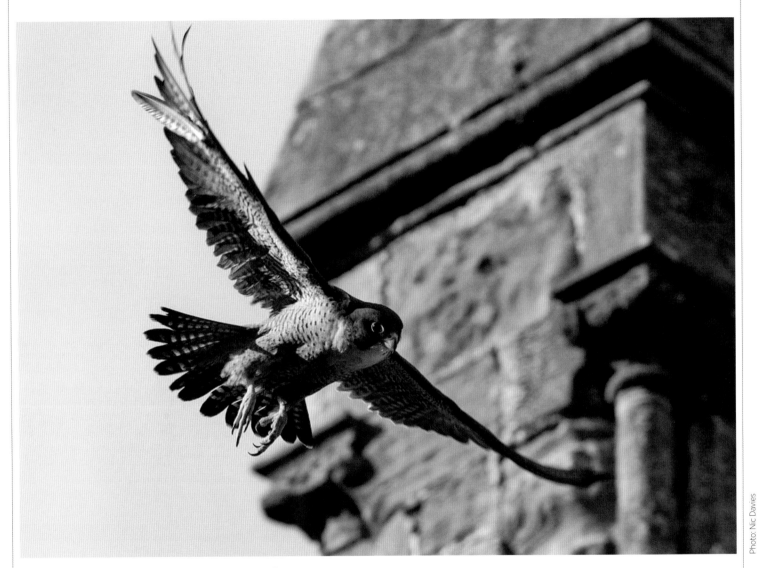

Photo: Nic Davies

Stoop to Conquer

The term 'stoop' is from falconry and
literally means to fall from the sky like
the plunging hawk to seize its prey
unaware. Here is the classic example
as the peregrine falcon 'falls' from its
perch in hot pursuit of a pigeon.

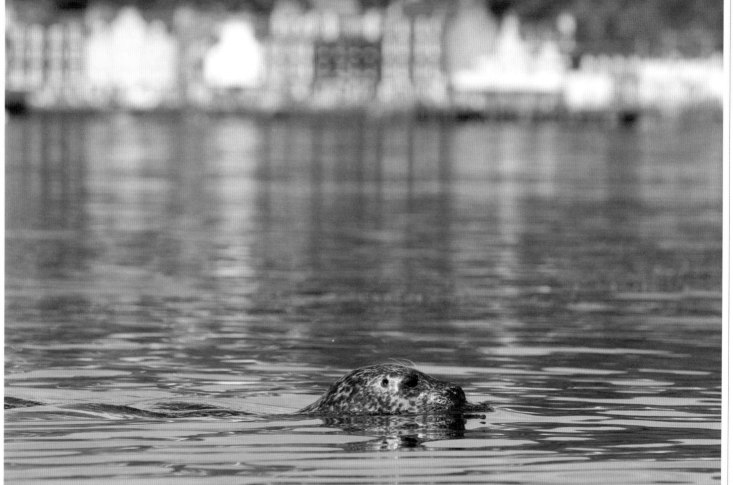

Harbour Seal

The harbour seal (also known as the common seal) in Tobermory Bay. The West Coast of Scotland is an important area for harbour seals and Atlantic grey seals.

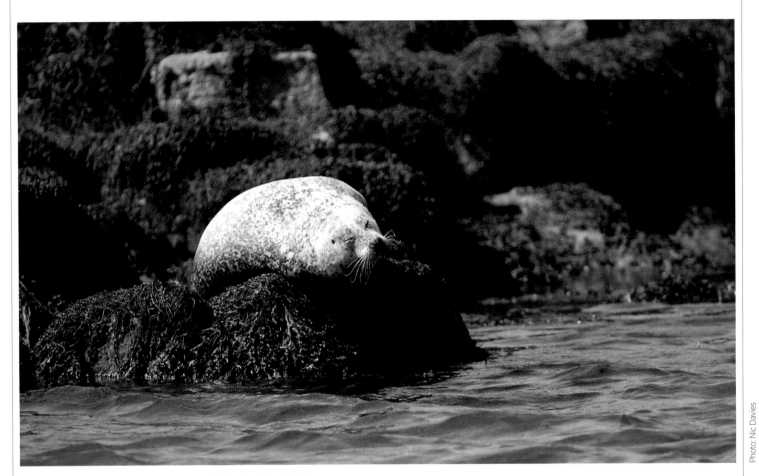

Balancing by a Whisker

A harbour seal on the rocks at Calve Island.
Tobermory Bay has its own small colony of
harbour seals, with the occasional visit
from the bigger Atlantic grey seal.

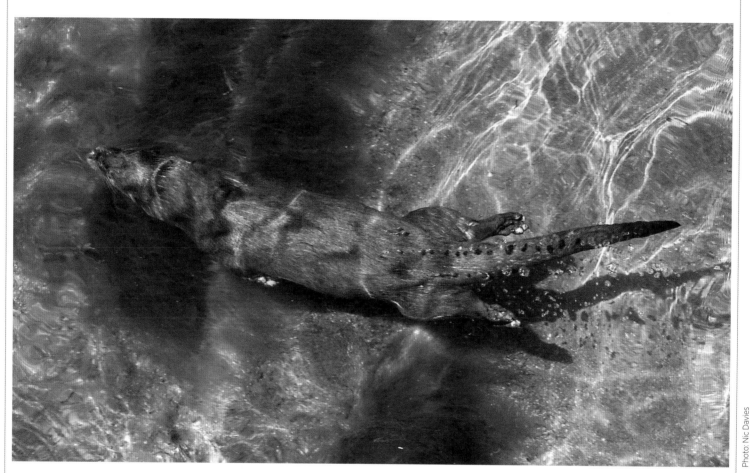

Tell-tale Trail

An otter swimming near the sea wall,
leaving a bubble trail in its wake.
Tobermory Bay often has resident otters.

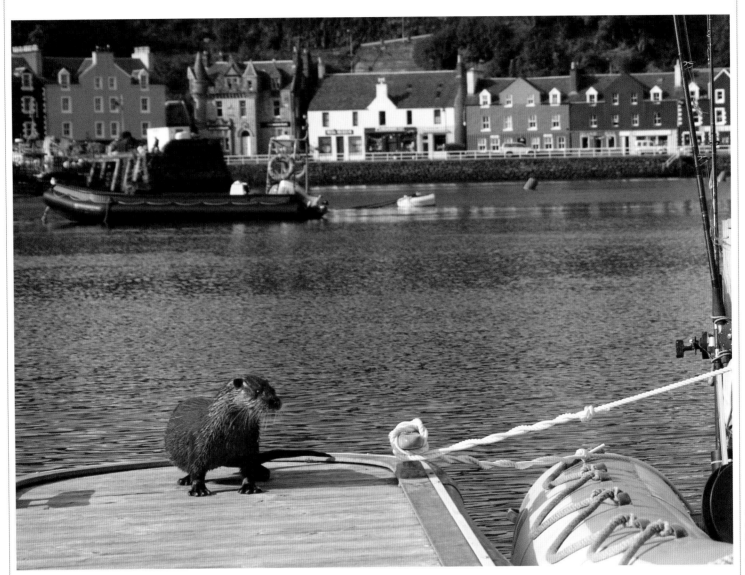

Admiring the Boats

One resident otter became very famous. Known locally as 'Elvis' he would often climb onto boats, sometimes making a bit of mess, which most owners took in their stride (literally!).

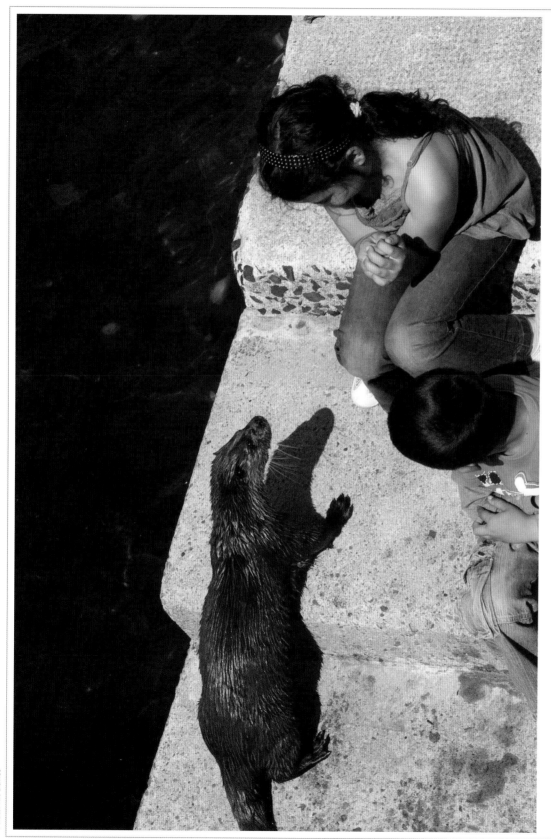

Photo: Nic Davies

'Elvis' making friends in Tobermory

Thousands of visitors enjoyed seeing Elvis the otter in Tobermory Bay but his increasing tameness did become a worry at the time. However, over the few years he was here he never bit anyone and passed from our company without a blemish on his name.

Diving Lesson

Otters are very active hunters. Always
ready to chase a tasty treat . . .

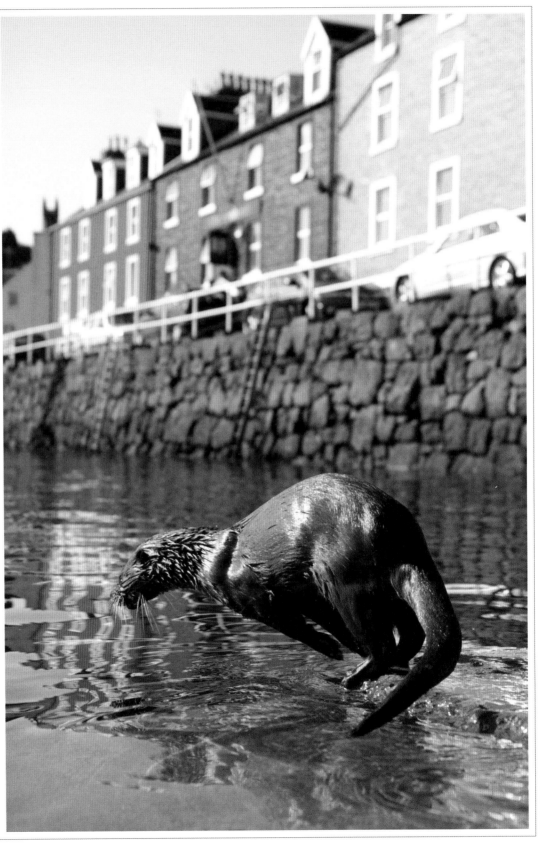

Photo: Nic Davies

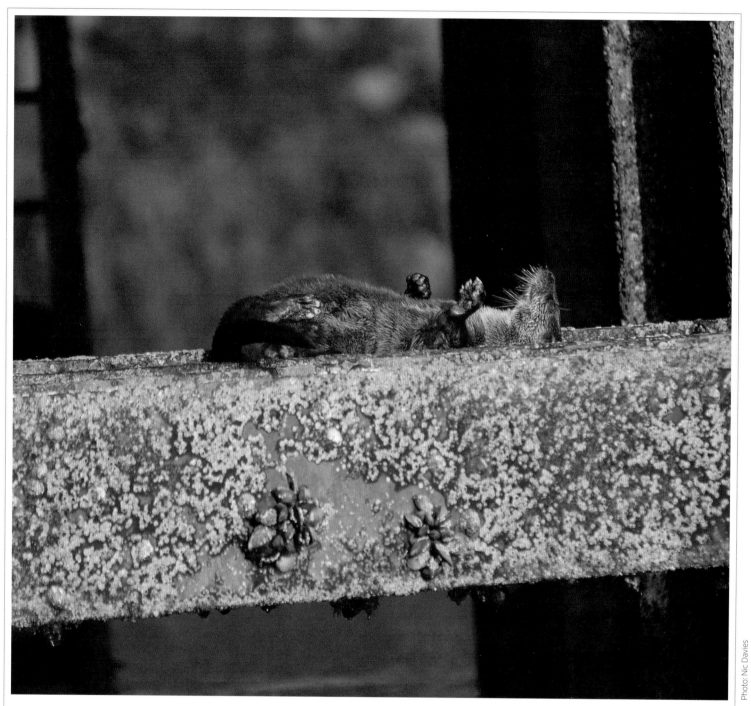

Lazy Lesson

. . . or enjoy a back rub out
of sight under the pier.

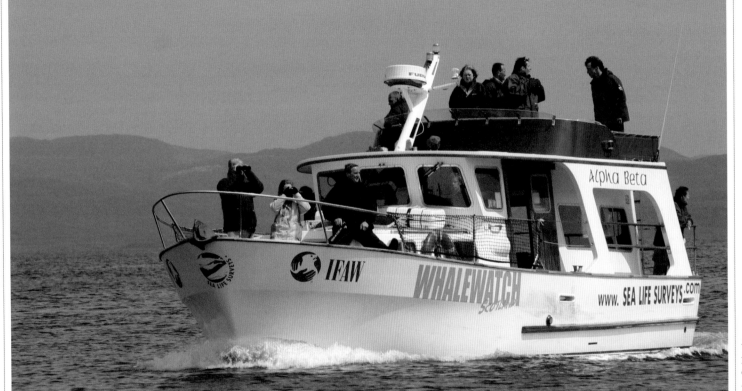

Photo: Brian Swinbanks

Searching for Fins

The seas round Mull are rich in fish and other marine wildlife. Whales, basking sharks, porpoise and dolphins are all spotted on the many charter boats going out from Tobermory.

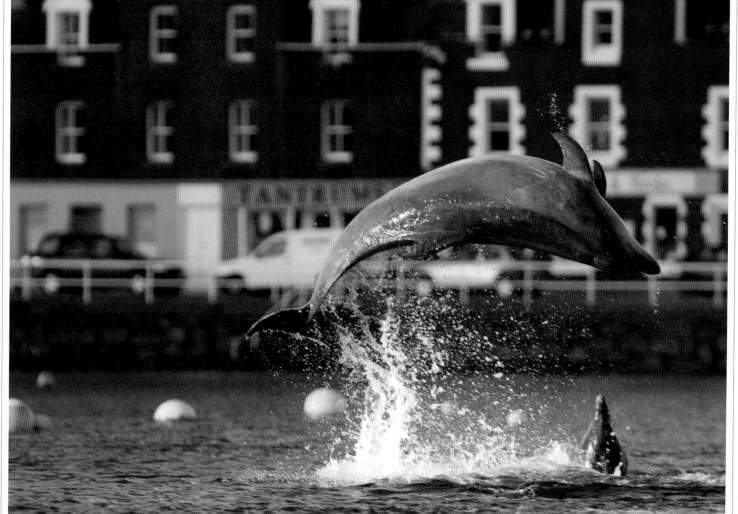

Photo: Nic Davies

Main Event on Main Street

Townsfolk and visitors to Tobermory are
occasionally treated to an impromtu
display by members of the Hebridean
coastal population of bottlenose dolphins.

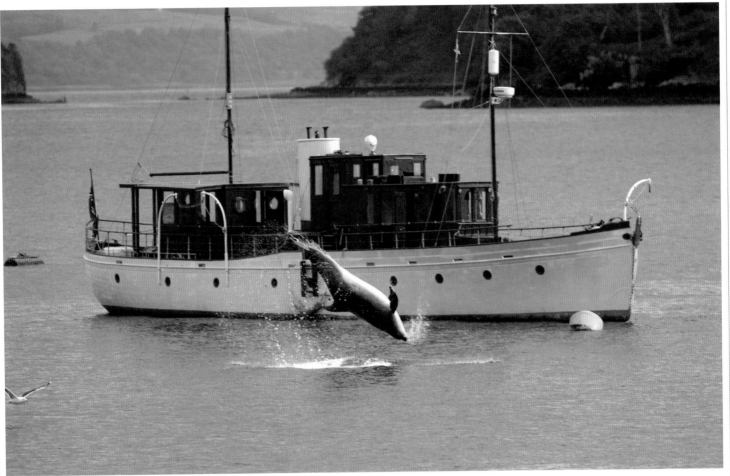

Photo: Nic Davies

Personal Salute

Bottlenose dolphin breaching near
Cordelia II, a 1929 gentleman's yacht built
at Dickies' yard on Loch Fyne for the
owners of Fyffes' bananas. Now listed in
the National Historic Ship Register she
served as a submarine patrol vessel in the
Clyde during the Second World War; now
owned locally.

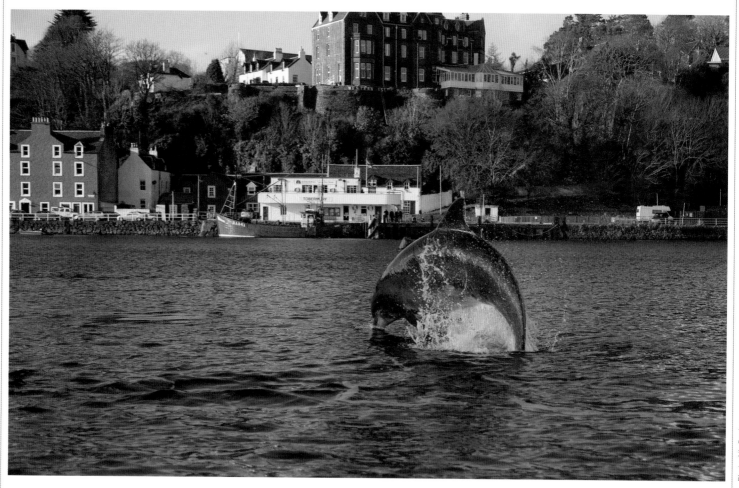

Having Fun in Tobermory Bay

The number of bottlenose dolphins
that range throughout the Hebrides
fluctuates through the years but there
are perhaps no more than sixty
individuals at any one time.

The Early Birds

As the sun rises geese take
flight past the Doirlinn.

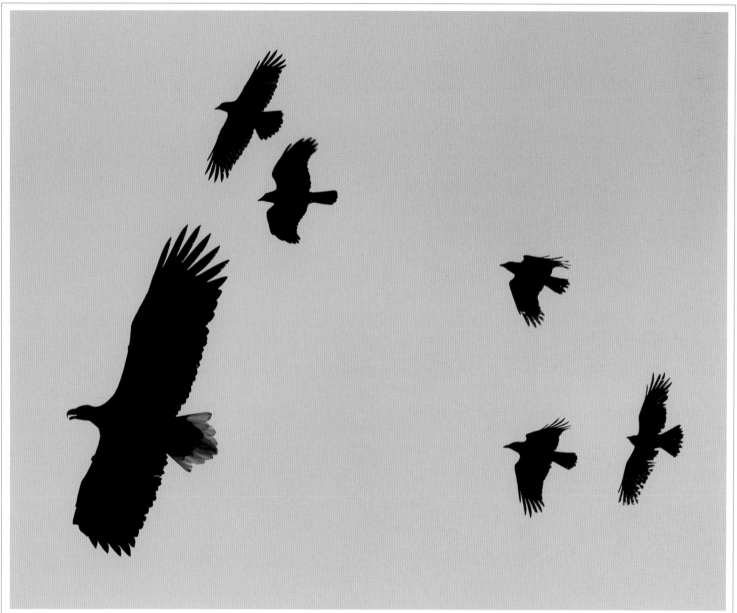

Photo: Nic Davies

Eagle Watch

A White-tailed eagle or Sea eagle being mobbed by corvids above Main Street. You don't have to travel far in Tobermory to see spectacular wildlife displays.

'We're Going to Need a Bigger Bay!'

A basking shark, the second largest fish in world oceans, cruises slowly past MacKay's Garage. These gentle giants are plankton feeders and since hunting for them was stopped in UK waters they are becoming more and more common around Mull.

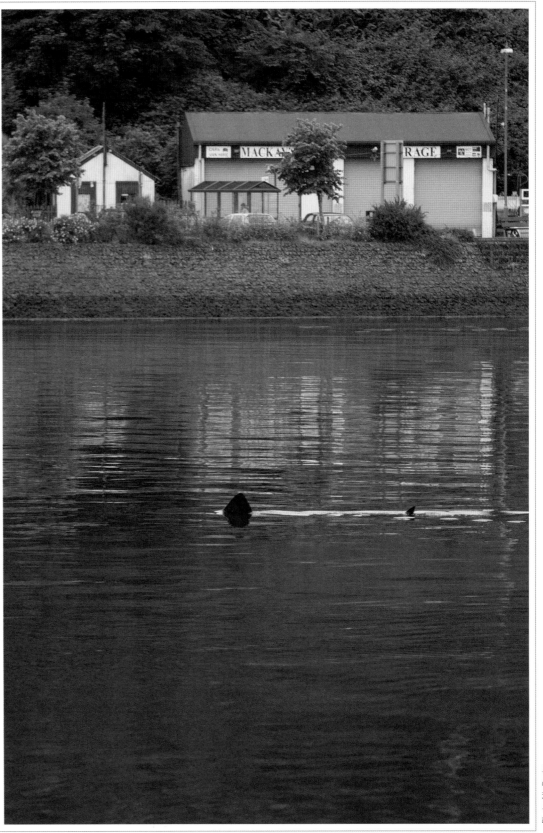

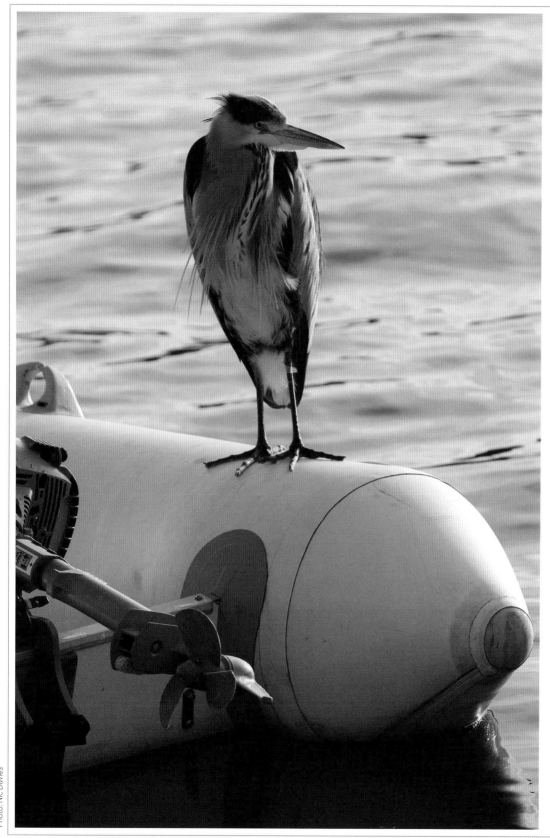

'Stern Heron'

A grey heron finds a matching perch. Herons are a common sight in and around Tobermory Bay.

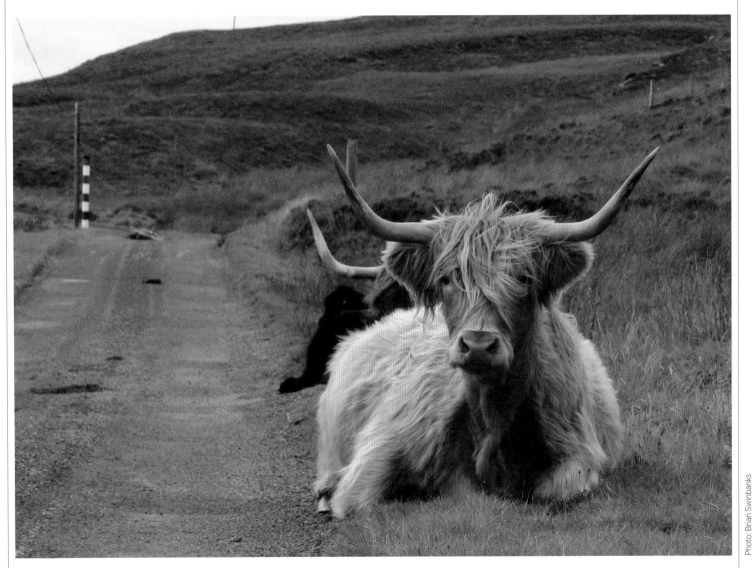

Highlander

North from Tobermory the road winds
past farms and forest and on to the
magnificent Glengorm Castle.

These farms are famed for organic
biscuits, cheese and delicious meat
from Mull's majestic Highland cattle.

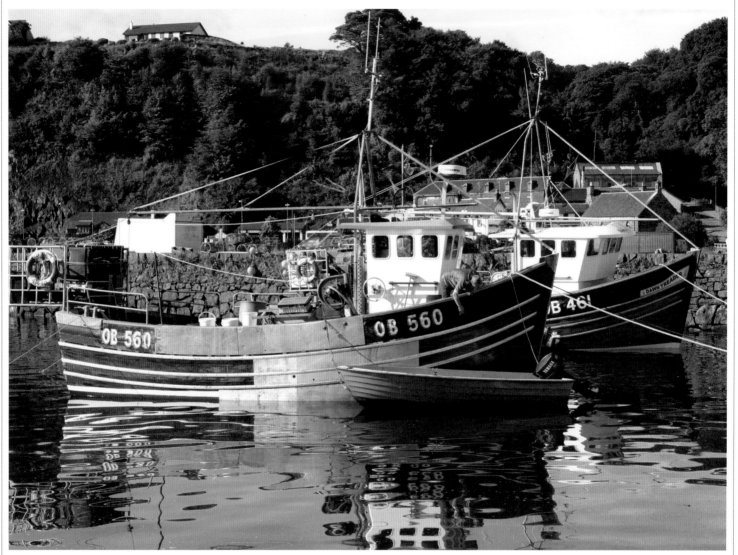

Photo: Brian Swinbanks

Ready to Be Painted

Every year the local fishermen tie up
their boats for a week to repaint and
varnish before going back to sea to
catch lobsters, prawns and scallops.
Commercial fishing is often a family
affair with boats being in the same
family for generations.

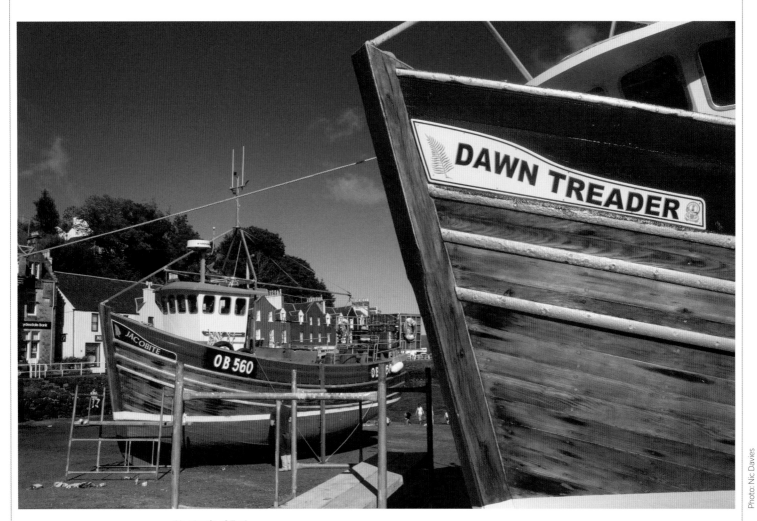

'Hap'orth of Tar'

Tobermory creel boats *Dawn Treader* and *Jacobite* out of the water for the annual maintenance. These beautiful and well-maintained wooden boats were built from Scottish larch.

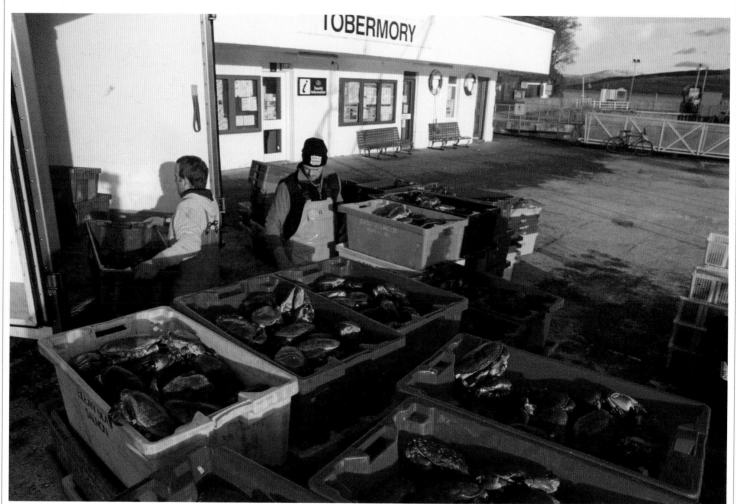

'Off to Market'

Loading the catch from local creel boat *Eilean Ban*. Lobsters and brown crabs cleaned and sorted ready for transport to markets all over Europe.

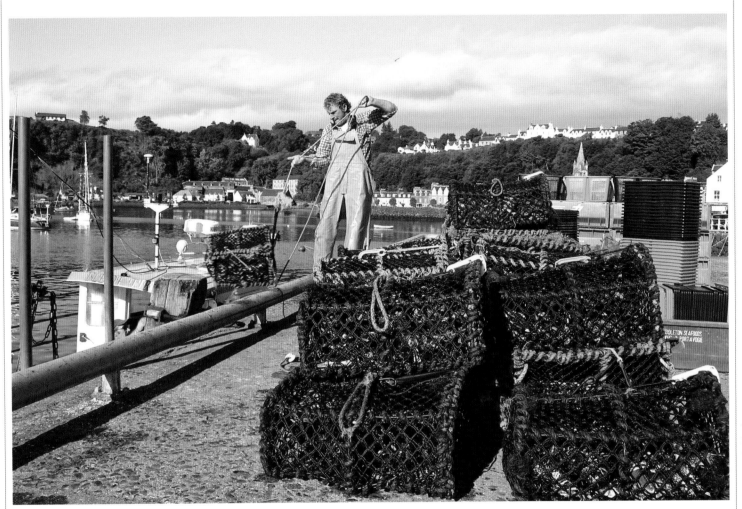

Landing the Catch

A fisherman hand-hauls gear and the catch onto the pier. Fortunately in recent years much more of the catch has been landed for use in local restaurants as Tobermory capitalises on its roots as a town established for fishing.

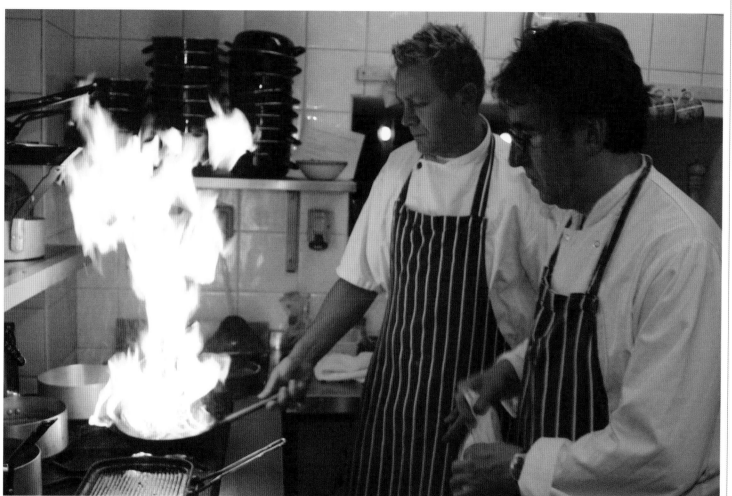

Photo: Brian Swinbanks

Red Hot Food

Today, delicious local foods are prepared in
Tobermory restaurants and hotels by
outstanding chefs. One of the joys of visiting
the town is to sample the many different
eateries with such diverse offerings as
Tobermory smoked trout, Mull cheeses and
local langoustines.

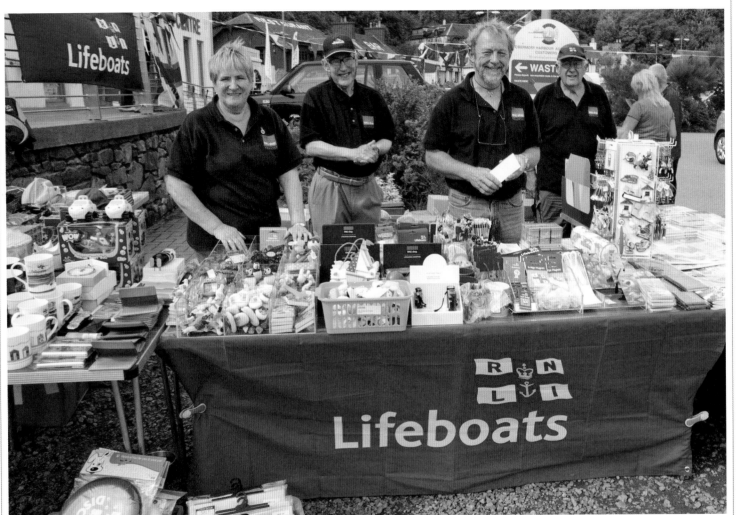

Photo: Dr Sam Jones

Stalwarts

Local volunteers man the Lifeboat
shop, raising funds to help Tobermory
RNLI lifeboat save lives at sea.

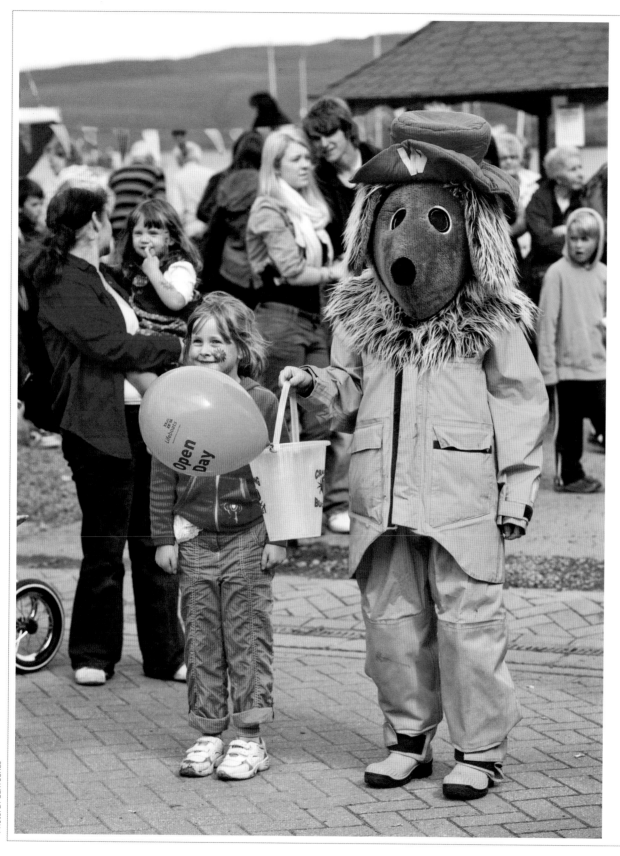

Photo: Dr Sam Jones

Lifeboat Day

Tobermory Womble in lifeboat kit, with a young RNLI supporter on Lifeboat Day. The Tobermory Womble, named after Tobermory town, traditionally wears a brown leather working apron and a black bowler hat.

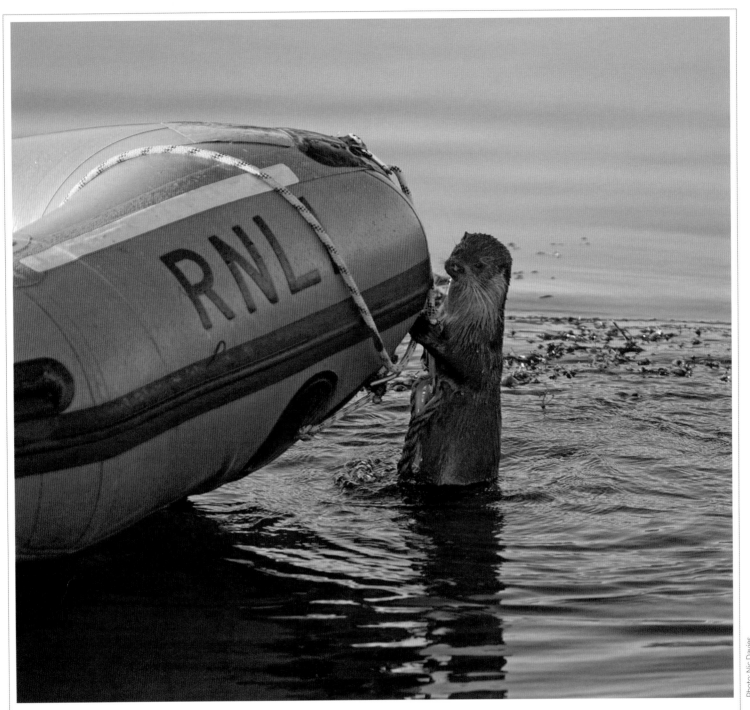

'Thanks for your Support'

A resident otter takes a shine to
the RNLI's boarding boat. It
became a favourite place for
lunch and rest.

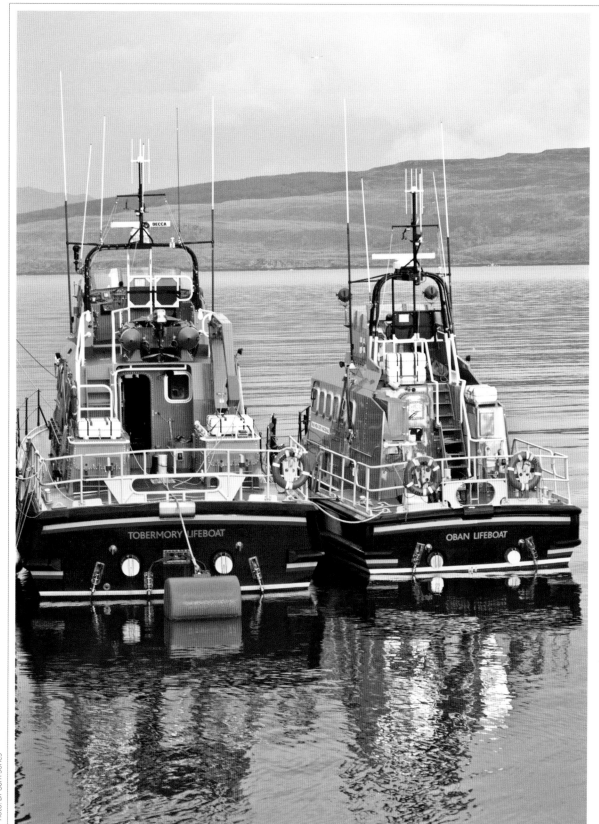

Little and Large

Oban's Trent Class lifeboat alongside Tobermory's Severn Class lifeboat. Both lifeboats are able to go out in all weathers up to 200 miles from the coast at speeds of 25 knots.

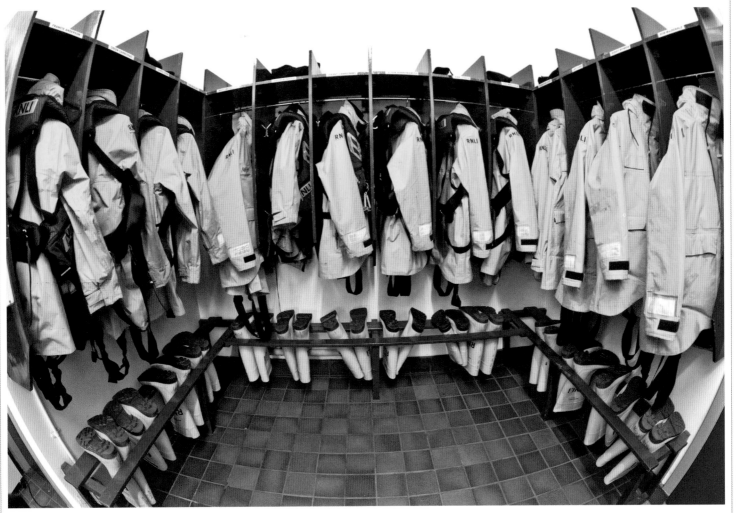

Photo: Dr Sam Jones

Get Kitted Up

Tobermory lifeboat crew's changing
room. The volunteer crew are on call 24/7
and can get called out at the shortest
notice. Their kit is designed to keep them
warm and dry in the worst winter
conditions even if, as has been known,
they are wearing pyjamas under the
'yellows'.

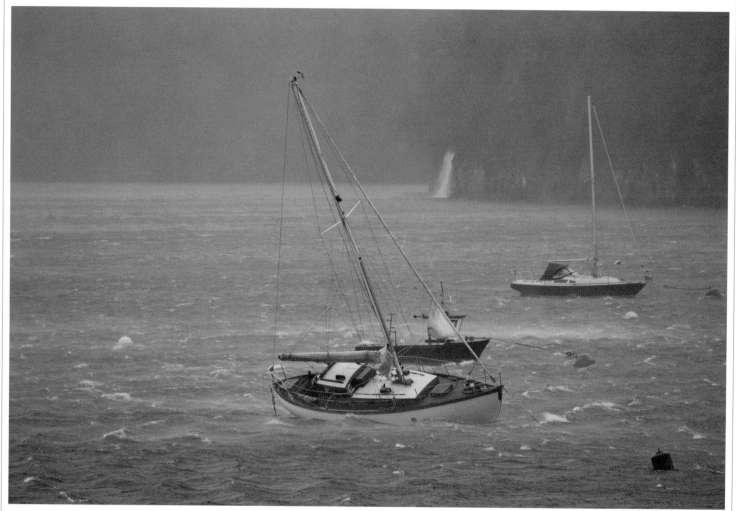

Photo: Dr Sam Jones

Westerly Gale

A westerly gale rips through
Tobermory Bay. Despite being one
of the most sheltered bays in
Scotland the sheer severity of some
winter weather whips the sea up.

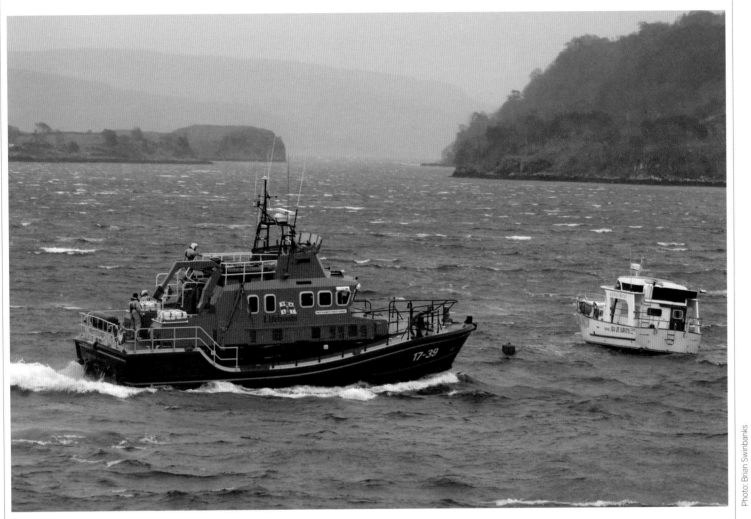

Photo: Brian Swinbanks

Rescue

The Tobermory lifeboat moves at
speed to a small boat in trouble on
the south side of the bay. All ended
well and the boat was safely towed
back into the harbour.

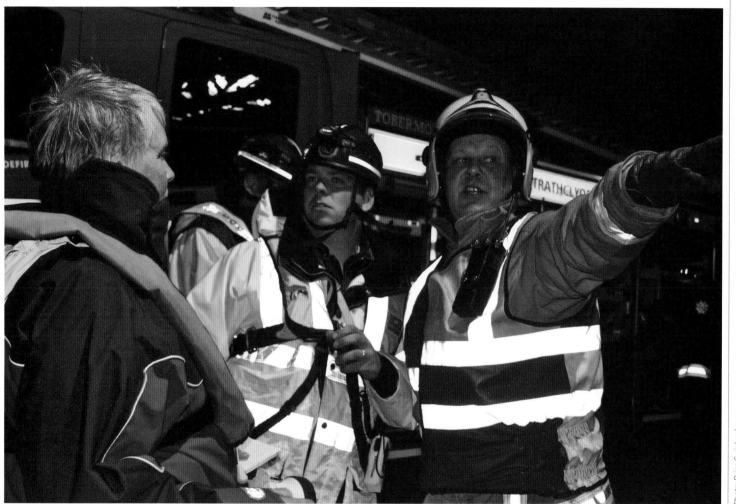

Practice Makes Perfect

To respond to different emergencies, regular exercises are held. In this case it's 'Fire on the Pontoons'. Led by the Fire Service and called by the local Harbour Association, all emergency services, including police, doctors, nurses, coastguards, lifeboat and crew, responded to the situation.

Zumba in the Rain

On an Atlantic-facing island rain is a part of life. Here local Zumba enthusiasts are undeterred by the weather in their efforts to raise money for a cancer charity.

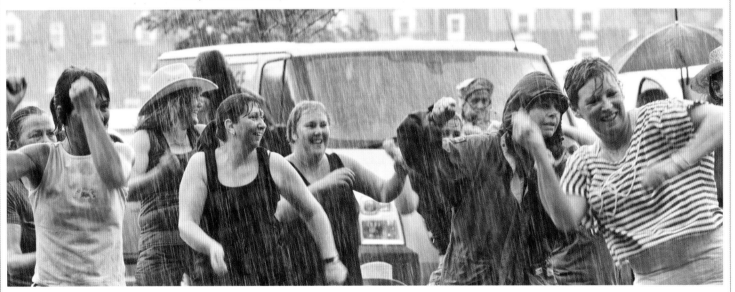

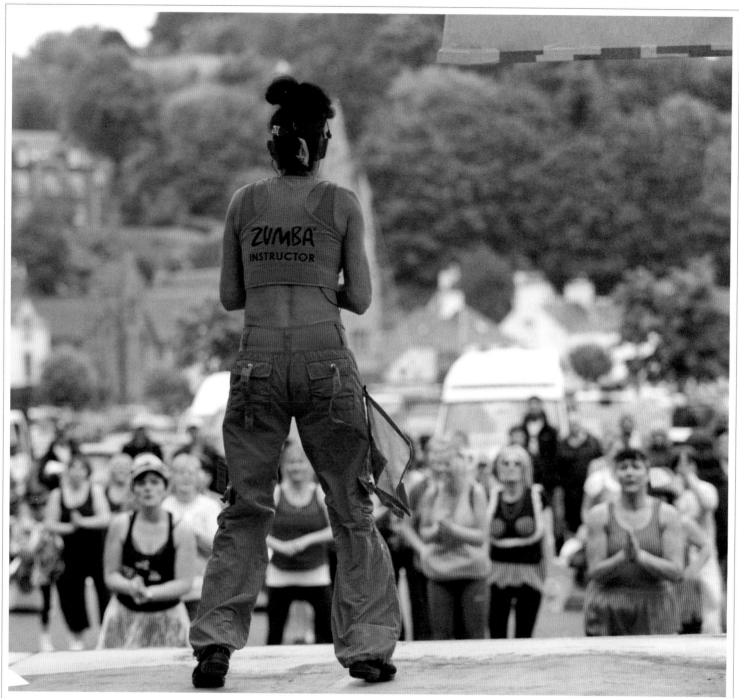

Photo: Dr Sam Jones

Zumbathon

Local voluntary groups are an
important part of Tobermory life.
Living on an island makes a sense
of community very strong.

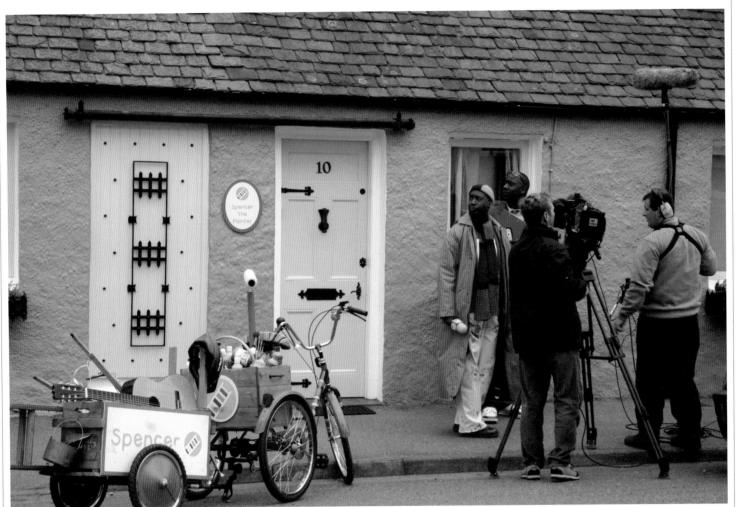

Photo: Brian Swinbanks

'What's the Story'

Tobermory was the setting for the children's television series *Balamory*. It was produced between 10 February 2002 and 14 April 2005 by BBC Scotland, with 254 episodes made. As the appeal of the series is to a pre-school audience that changes every few years, sufficient episodes were soon made to be continually rotated.

For a few hectic years the programme brought thousands of wide-eyed youngsters to the town searching for the stars, who of course did not live in Tobermory!

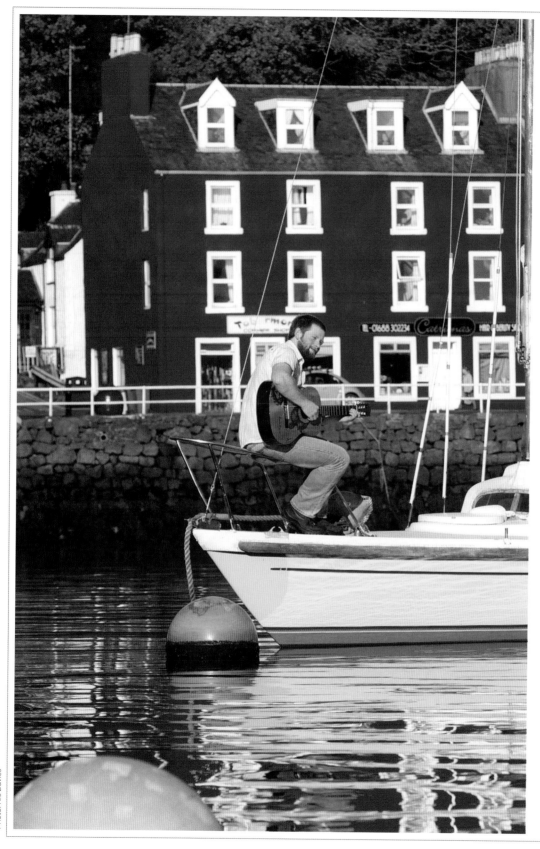

'Sound Waves'

Tobermory's music scene is vibrant, with local musicians practising anywhere, anytime!

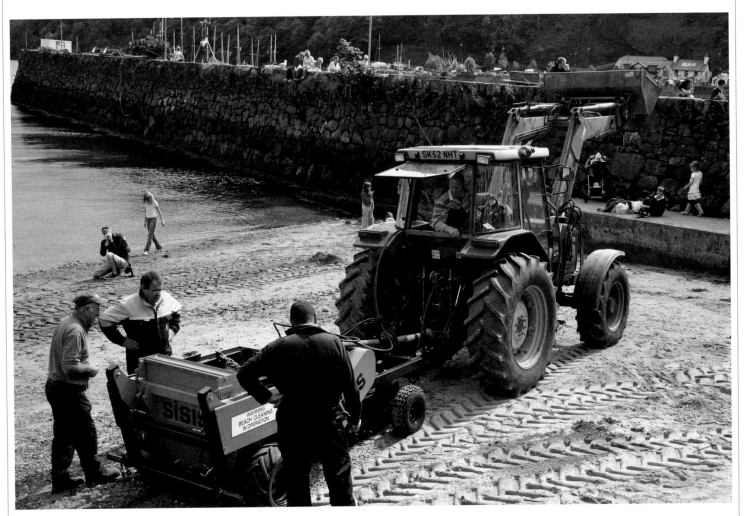

Beach Cleaning

With the help of a donation from
a former Tobermory resident the
community bought a special
machine to help keep the local
beach clean.

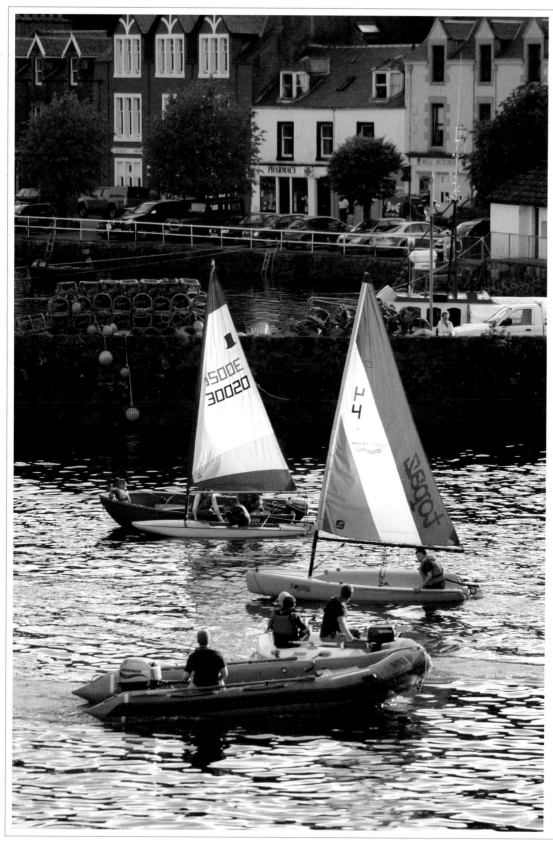

Yacht Club Cadets

The next generation learns to sail under the watchful eyes of a 'close by' rescue boat.

The Main Street March

The Mull Highland Games takes place every July in Tobermory. The march to the Games is led by the Clan Chief of the MacLeans (central) and travels the Main Street on its way to the Games Field.

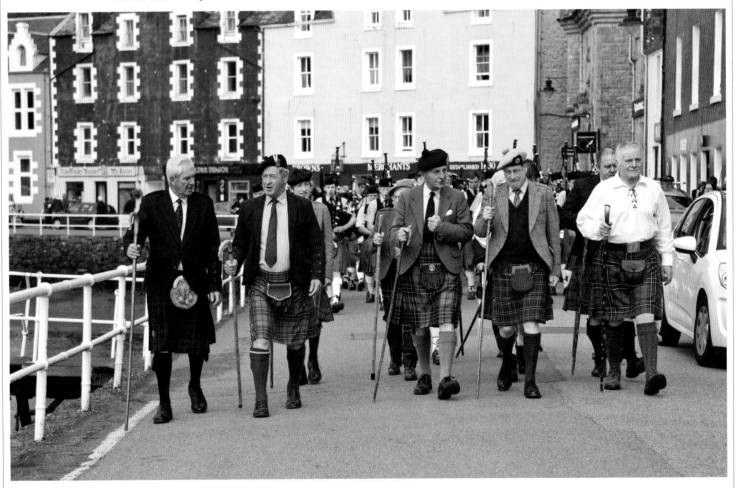

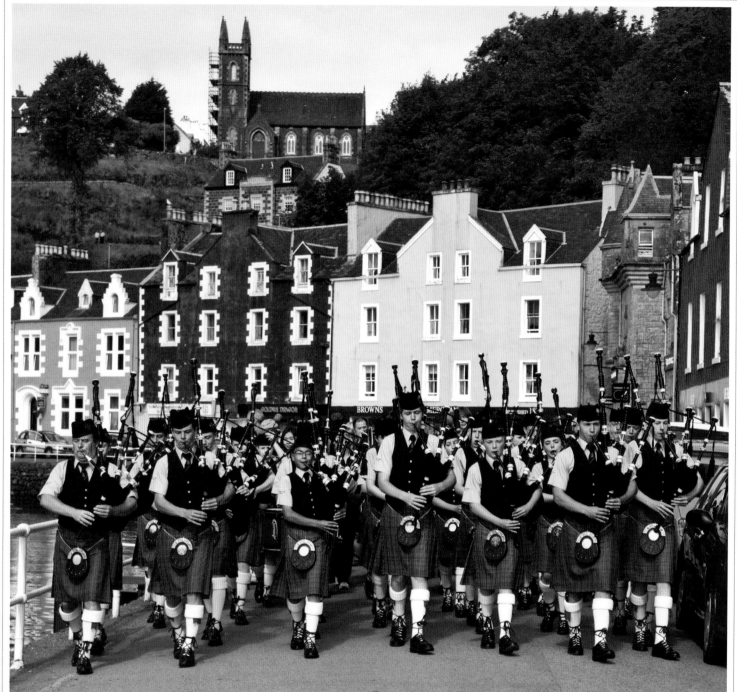

The Band

The March is traditional, with the Highland Pipe Bands very much to the fore, and ends at the Games Field above Tobermory on the golf course. This is a magnificent setting overlooking the Sound of Mull and Morvern. This backdrop only adds to the drama unfolding on the Games Field.

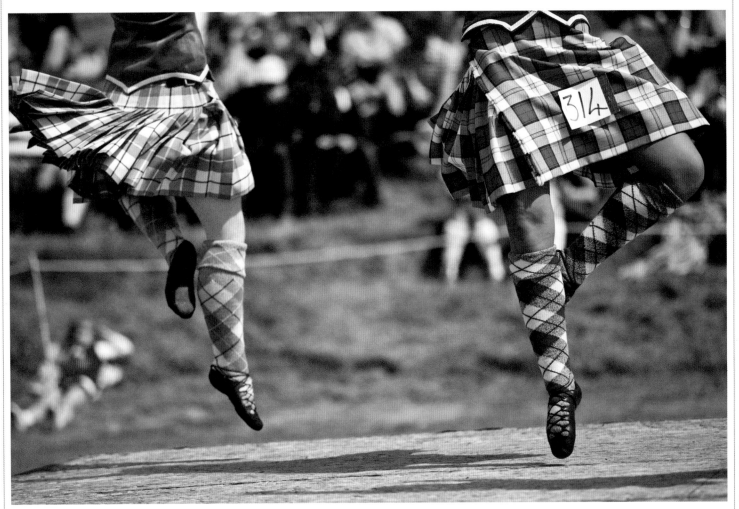

Photo: Dr Sam Jones

Fleet of Foot

The Mull Games includes all the traditional competitive events.
Highland dancing requires technique, stamina and strength
and is judged on technique.

In Highland dancing, the dancers dance on the balls of the
feet and the dance involves not only a combination of steps
but also integral upper body, arm and hand movements.

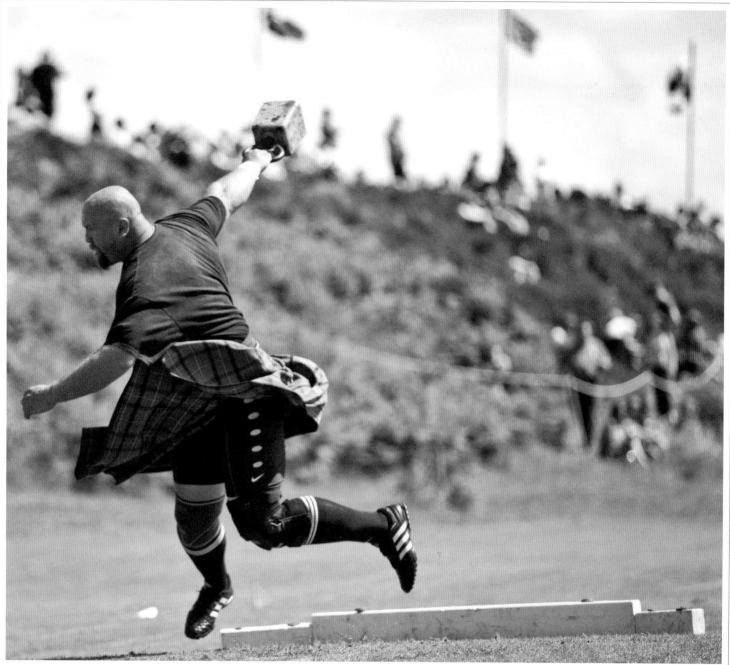

Photo: Dr Sam Jones

The Heavies

The most recognisable characters at the Mull Games are the Heavies. In the Tobermory setting, watching these traditionally kilted strongmen undertaking various tests of strength makes for an exciting and invigorating atmosphere, whether the objective is to throw a heavy weight or that most recognisable event of all, 'Tossing the Caber'.

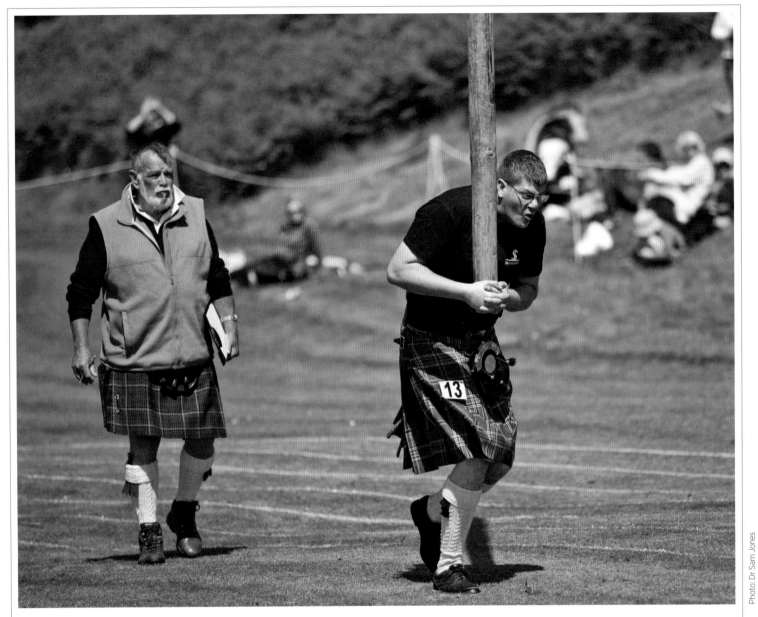

Tobermory Caber Toss

The objective is to toss the caber (taken from the Gaelic word 'cabar' or 'kaber' which refers to a wooden beam) so that it turns end over end. The tosser balances the caber upright, tapered end downwards, against his shoulder and neck, and then walks or runs a few paces forward to gain momentum. He then flips the tapered end upwards so that the large end hits the ground first and, if well tossed, the caber falls away from the tosser. The straightest end-over-end toss scores highest.

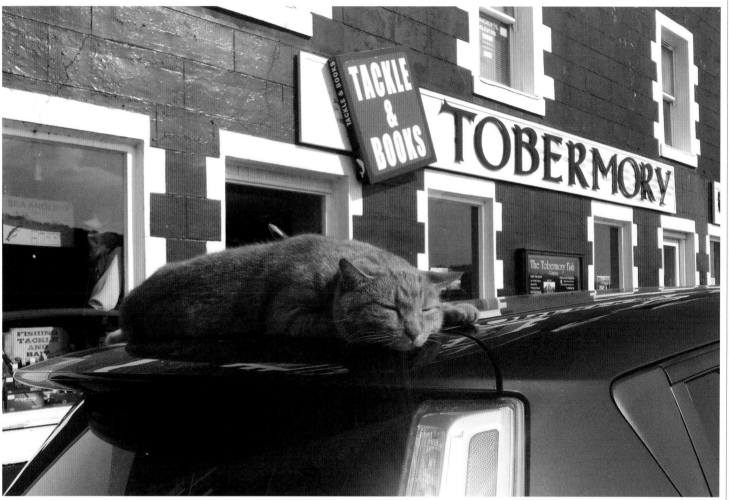

Photo: Brian Swinbanks

Tobermory Hitches a Ride

A few years ago two cats became the stars of an advertising campaign by the Tobermory Distillery. Called Tobermory and Ledaig, after the two local malt whiskies, their fame spread far and wide and soon they were being featured on Facebook. One of the cats went on to star in his own childrens book, *The Tobermory Cat*.

Tackle and Books Signing

Debi Gliori is a Scottish author and illustrator of over 80 children's books. She is seen here signing copies of *The Tobermory Cat*. A frequent visitor to Tobermory, Debi has won several notable awards.

Photo: Brian Swinbanks

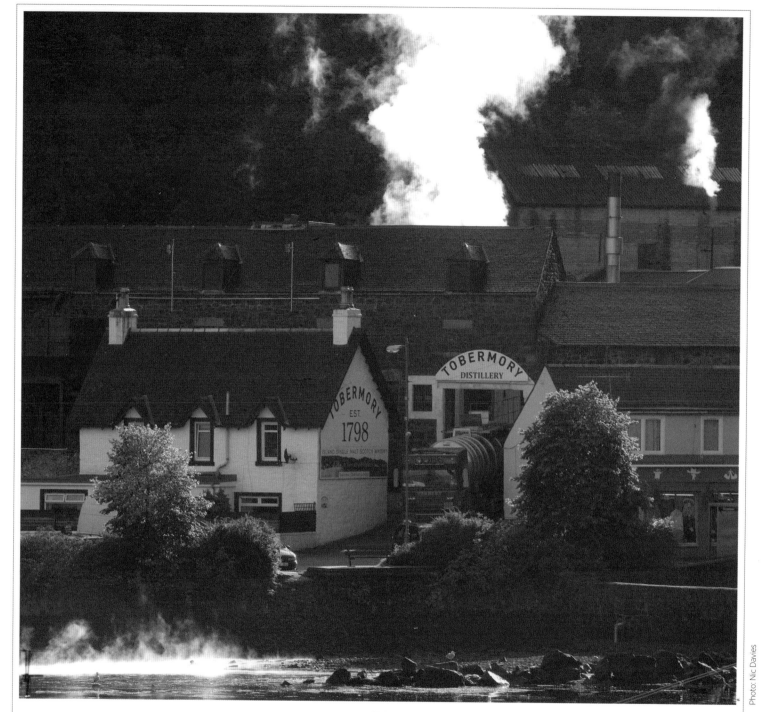

'A Dreamy Dram'

The Tobermory Distillery was originally founded in 1798 by
John Sinclair, under the name Ledaig (pronounced 'led-
chigg'). Although the distillery has closed a few times over the
years it is now going strong and is a good local employer.
Today, Tobermory is the only distillery on the Isle of Mull.

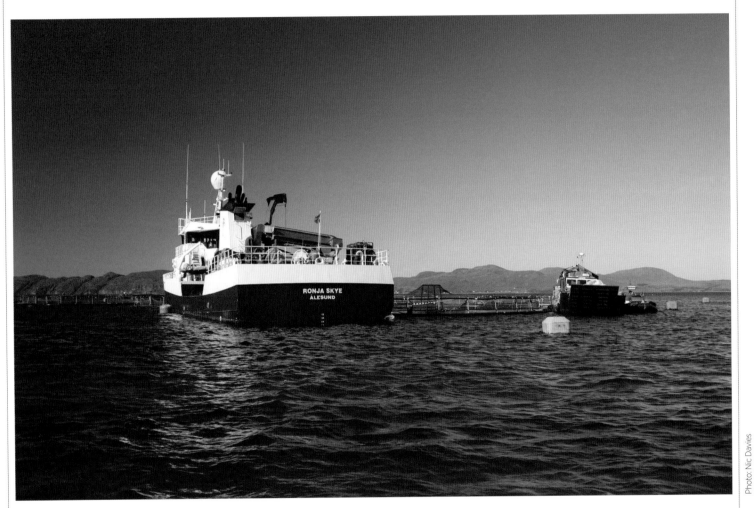

Bloody Bay Fish Farm

The Battle of Bloody Bay was a fifteenth-century naval battle between John MacDonald, chief of Clan Donald, and his son, Angus Og MacDonald, who emerged victorious and later seized power from his father.

Bloody Bay is now home to sea-farmed salmon. This industry employs many local people from both Tobermory and the wider Isle of Mull. The boat alongside is full of clean fresh seawater and is used to transport live fish to different locations.

Photo: Brian Swinbanks

Treasure Hunt

For centuries divers have visited
Tobermory Bay in the hope of finding an
elusive treasure worth £30 million. The
treasure was reputed to be aboard a
Spanish Armada vessel which was blown
up and sank in the bay in 1588. Although
some artifacts have been found, to date
all the attempts have to show are holes
on the seabed and no treasure.

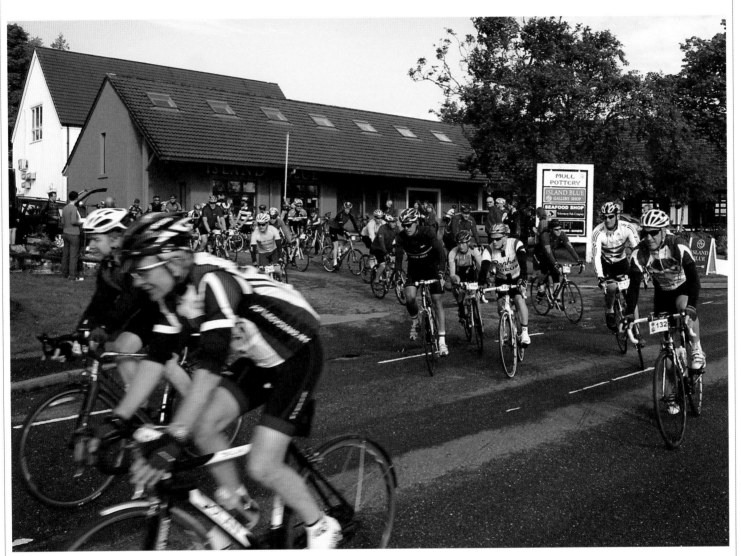

Photo: Brian Swinbanks

Isle of Mull Sportive

Starting at Baliscate, a craft and local produce
centre as you enter Tobermory, the Mull
Sportive is now an annual bicycle race round
the island's single track roads. The event
brings hundreds of cyclists to Tobermory.

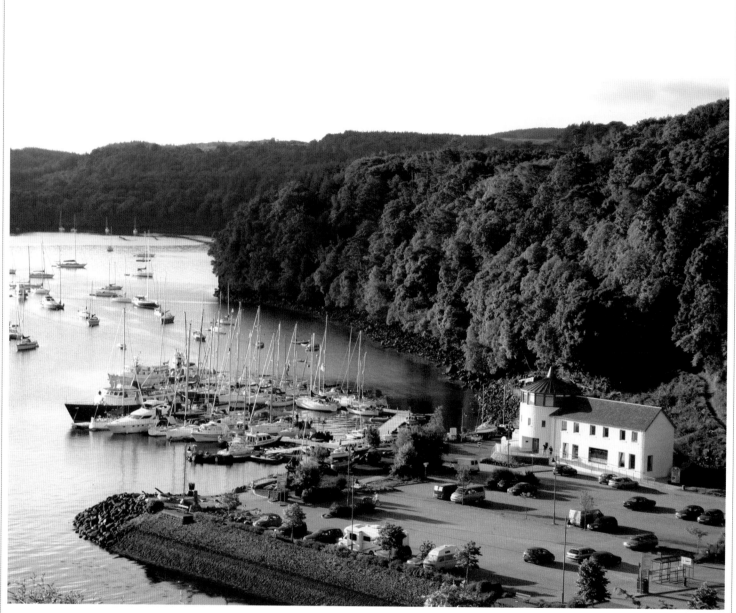

Photo: Brian Swinbanks

Taigh Solais

Founded in 1983, the Tobermory Harbour Association is a community company that owns, manages and maintains many of the facilities within Tobermory harbour. Most noticeable of these are the pontoons and the harbour building, Taigh Solais (the lighthouse).

Tobermory harbour is a key stepping-stone to other islands and remote rural communities up and down the Scottish West Coast.

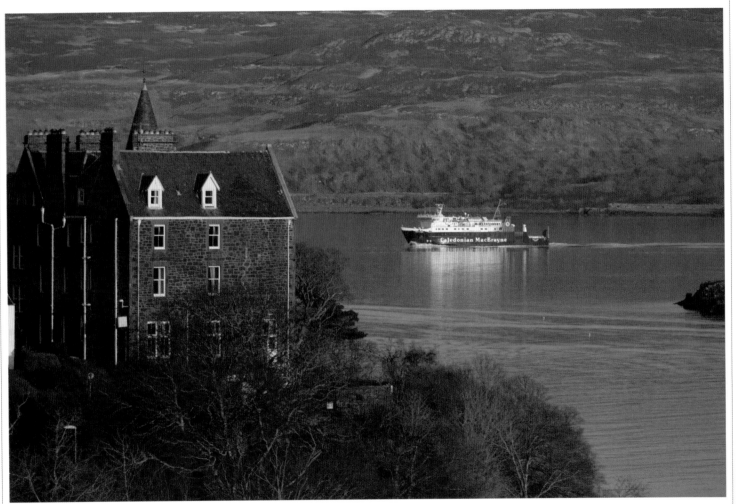

'Homeward Bound'

Calmac ferry *Lord of the Isles* heading up the Sound of Mull on
her way to Coll and Tiree. The last time that a scheduled ferry on
this route called into Tobermory was in 1997. Overnight, a trip to
Coll or Tiree changed from two hours to up to two days.

The Western Isles Hotel (in the foreground) was opened
amid great fanfare in 1883 and promoted the attractions of
Tobermory's sea bathing. The views from this landmark hotel are
spectacular and have been enjoyed by many famous residents.

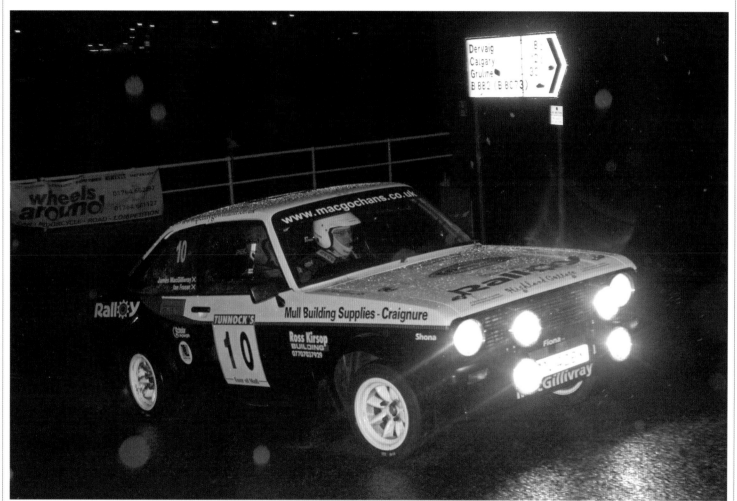

Photo: Nic Davies

'No holding back on Back Brae'

Every October, Tobermory hosts what is
known, with a lot of justification, as the 'best
rally in the world'. The Mull Car Rally attracts
well over 100 entries from all over Britain and
locally. Drivers race on Mull roads in several
stages and on several different courses.
Some of the races are during daylight and
some are staged at night.

The Santa Dash

An annual fundraising Santa Dash around the town, seen here passing the Tobermory Town Clock. Isabella Bird, a Victorian world traveller, left money in her will to build the clock in memory of her sister Henrietta. The clock was erected in 1905.

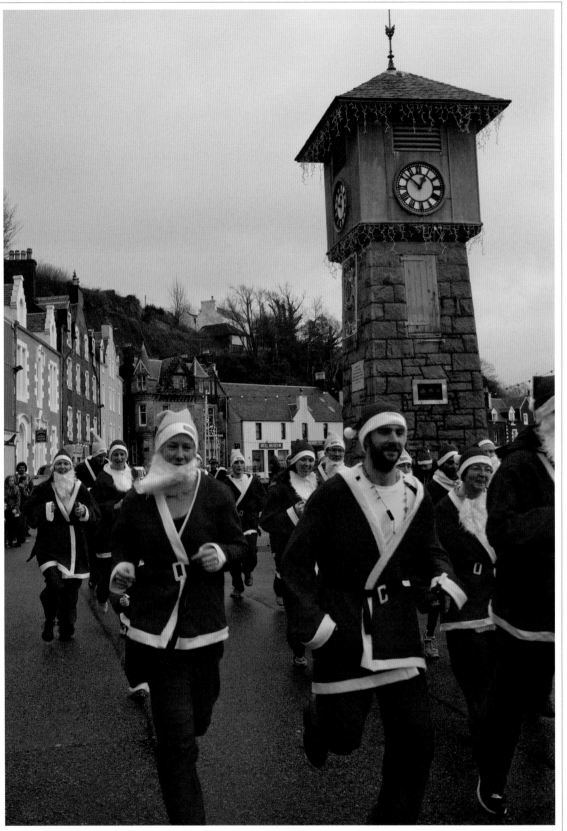

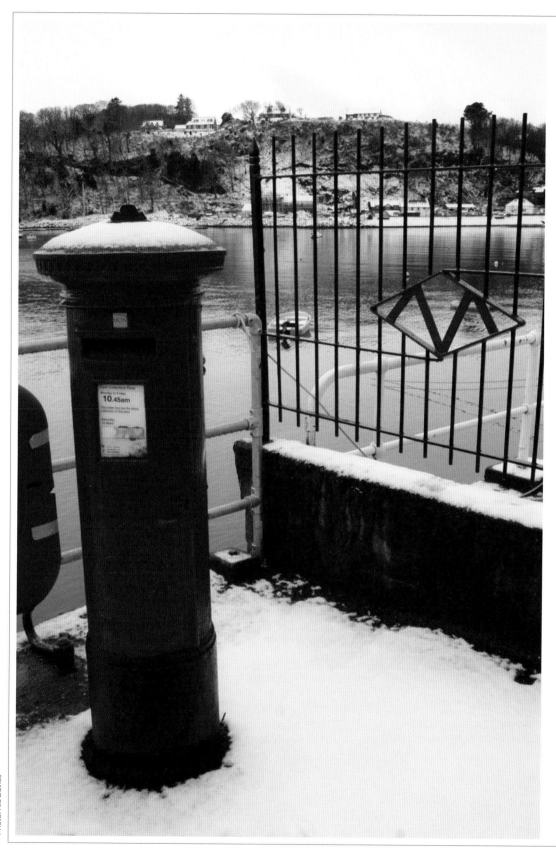

'Vacant Post'

A very rare example of an Edward VIII postbox can be found by MacBraynes Pier in Tobermory. Edward famously abdicated in 1936, leaving his brother George VI to take on the role of monarch.

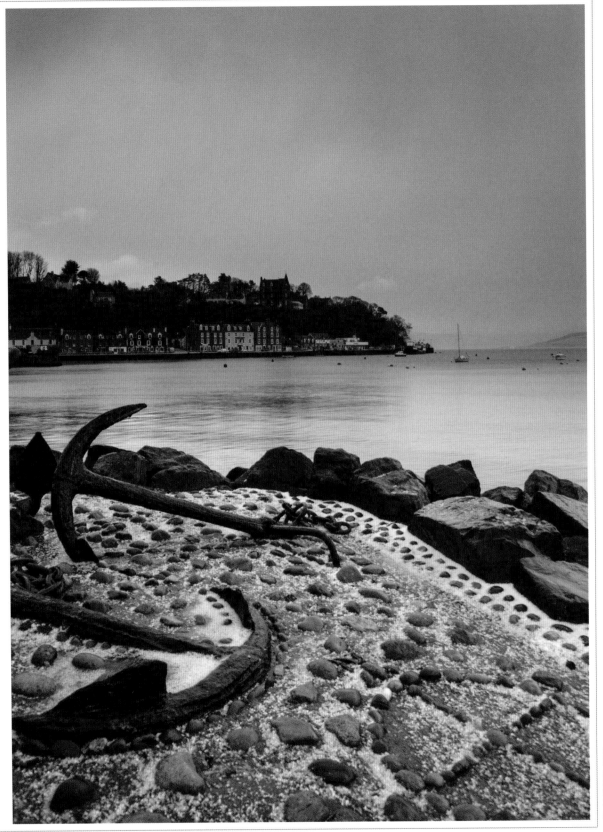

Winter's Bay

Historic anchors were recovered from the sea in 1999 when the new car park and harbour wall were built. Many of the anchors, some hundreds of years old, now form part of the harbour landscape.

Photo: Dr Sam Jones

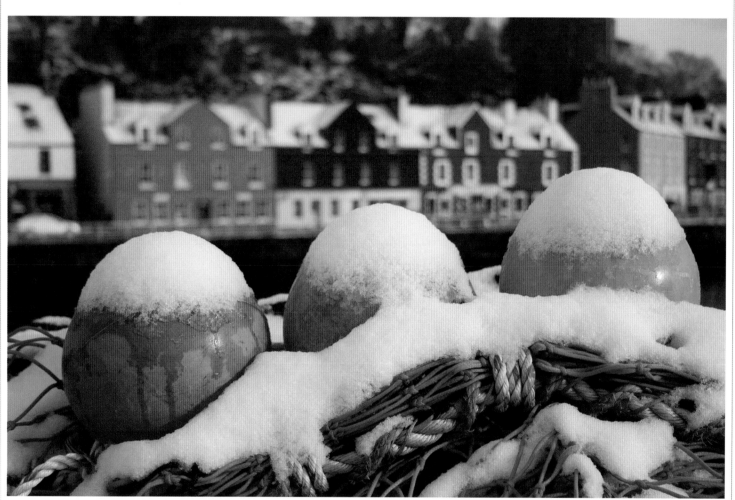

Christmas 'Buoybles'

Snowfall in Tobermory is rarer than most
people would believe and a white Christmas
is a real treat for local kids and adults alike.

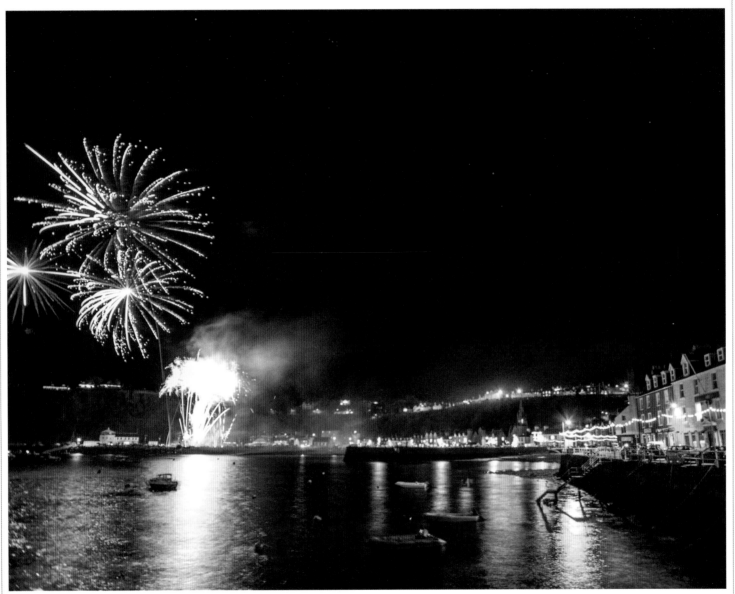

After the Bells

Started in the year 2000 to
celebrate the Millennium, 'Round
the Clock' has become a major
event that attracts many friends,
relatives and visitors who come
to Tobermory and have fun.